PAINTING SOLUTIONS

HANDS, FACES AND FIGURES

The Sunset House, Arthur Maderson, *oil*

PAINTING SOLUTIONS

HANDS, FACES AND FIGURES

ANGELA GAIR

THE WELLFLEET PRESS

WELLFLEET

A QUARTO BOOK

Published by Wellfleet Press
110 Enterprise Avenue
Secaucus, New Jersey 07094

ISBN 1-55521-720-6

This book was designed and produced by
Quarto Publishing plc
The Old Brewery, 6 Blundell Street
London N7 9BH

Publishing Director Janet Slingsby
Art Director Moira Clinch
Assistant Art Director Chloë Alexander
Picture Manager Sarah Risley
Picture Researcher Bridget Harney
Senior Editor Kate Kirby
Designer John Grain
Demonstrations David Curtis
Photographer Paul Forrester
Special thanks to David Curtis, Stefanie Foster, Carmen Jones
Typeset by Bookworm Typesetting
Manufactured in Hong Kong by
Excel Graphic Arts Company
Printed in Hong Kong by Lee-Fung Asco Printers Limited

CONTENTS

Introduction 6

INTRODUCTION

Since prehistoric times, peoples of every culture have been moved to create lasting images of themselves and their fellows. Despite the advent of photography there is a continued fascination with the human form among artists, and the traditions of portrait and figure painting are as strong today as they ever were. There will always be painters who will find new ways of investigating the psychological and philosophical implications that are embodied in human subjects.

Nevertheless, faces and figures are among the most intricate and challenging subjects, and there is some truth in the old adage that "if you can paint people you can paint anything". Many people regard portraits and figures as difficult subjects, requiring a detailed study of anatomy, but in fact this is not really necessary, especially if you intend studying the clothed figure. True, a basic knowledge of anatomy will help you to understand the underlying structure of the body, but animation is far more important than anatomy when it comes to depicting lifelike figures. Learning to identify the poses and gestures that reveal something of the spirit of your subject, and conveying these expressively through your choice of technique, colour and composition, these are the most satisfying aspects of figure painting and portraiture.

One of the best ways to start drawing or painting the figure is to join a life class, where models are provided for you to study. Failing that, get your friends and family to pose for you. Above all, carry a sketchbook with you at all times and sketch figures constantly – on your journey to work, at a beach, in the street, anywhere. There is no better way than this to hone your skills and sharpen your creativity. Visits to museums and art galleries are also a great source of inspiration, and it can be a fruitful lesson to make copies of paintings and drawings by the masters, so long as this is done in the spirit of enquiry and learning and not just as a slick and easy exercise, aimed at achieving instant results.

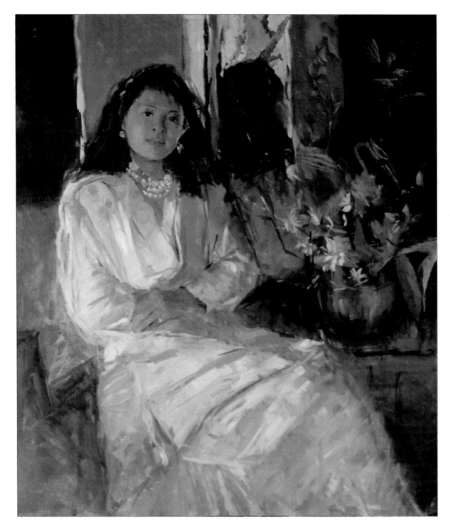

Wong Mei Wan, *Jane Corsellis*

Copying the work of a master allows you to gain a "hands-on" sense of that master's technique, his use of colour, his compositional sense, and even his emotional reaction to his subject. Strangely, it is through this process of immersion in the work of other artists that we discover our own artistic style – our own way of saying "this is what I feel about my fellow human beings". I hope that in this book you will find valuable instruction, and that through it you will find inspiration for the development of your own ideas.

"Anatomy, that dreadful science! If I had had to learn anatomy, I would never have made myself a painter!"
Jean Auguste Dominique Ingres

The Local Vicar Tom Coates, *oil on canvas*

PART 1

PORTRAITS
AND HEADS

"OF ALL THINGS, THE PERFECTION IS TO IMITATE THE
FACE OF MANKIND"
NICHOLAS HILLIARD

PROPORTIONS OF THE HEAD

Are there any guidelines for positioning the features of the face?

Inexperienced artists frequently pay too much attention to the individual features of the face, often drawing them too large in proportion to the head as a whole. The positioning of the features may also be confused, the most common error being that the eyes are placed too high up on the head. When drawing a portrait head, it is important to get the basic proportions correct, because it is these which help to produce a good likeness. While recognizing that it is partly the differences in proportion which distinguish one head from another, it is useful to start by getting the basic, or "normal", head proportions firmly fixed in your mind.

The task of drawing the human head becomes much easier if you break it down into manageable portions: first, draw an outline of the head, then sketch guidelines to enable you roughly to position the features, and finally adjust the position of the features, if necessary, according to the individual face before you.

The easiest way of visualizing the shape of the head is to think of it as an egg sitting on top of the cylinder of the neck. Seen from the front, the egg is upright, while from the side it is tilted at an angle of roughly 45 degrees. Having established the shape of the head, you can position the

Head proportions

The average shape of the head is enclosed frontally in a rectangle (below left). The same head in profile fits into a square with sides equal to the height of the frontal rectangle (below right). As a general guide, the head comprises two equal ellipses – one positioned vertically and one horizontally. Use the rule of halves to find the correct positions of the features; sketch guidelines to help you, and then draw in the features around them. Remember, though, that the proportions will vary slightly from one individual to another.

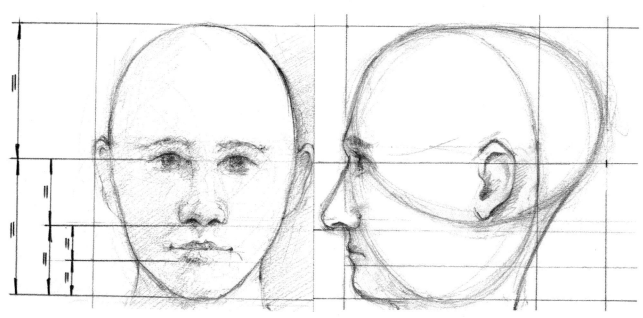

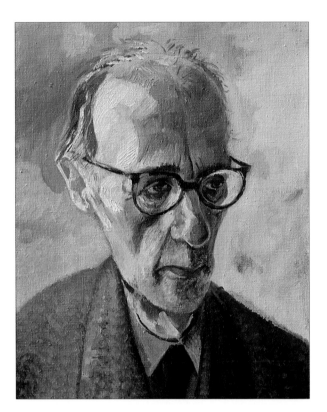

Small Portrait of Cecil
Rosalind Cuthbert, *oil*
In this painting, the artist has deliberately elongated the model's pale, gaunt face in order to accentuate the poignant mood of the portrait. As a portraitist you are an interpreter of human character, personality and emotions; don't allow the "rule of halves" to become a mechanical device that blocks your creative flow, but use it alongside your own observations of the person you are painting.

Timothy as a Baby Stephen Crowther, *charcoal on paper*
In babies and young children, the cranium and forehead are proportionately larger than those of an adult, and the facial features appear to be set much closer together. The nose, mouth and chin are tiny and soft, and the eyes are large and bright.

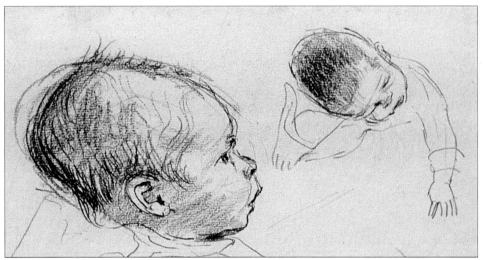

features, and here the "rule of halves" is a useful guide. Lightly sketch a horizontal line halfway down the head; this marks the position of the eyes, and from here it is easy to gauge the eyebrow line. Sketch a line midway between the eyebrow line and the base of the chin in order to find the position of the base of the nose; then draw a line midway between the base of the nose and the chin to find the line of the lower lip. Finally, draw a vertical line down the centre of the head to guide you when positioning the facial features on either side.

Remember that it is partly the differences in proportion that distinguish one head from another. The rule of halves is intended only as a guide, so do not follow it rigidly or you will end up with unlifelike portraits. It is, however, a useful basis from which to start. Once your guidelines are drawn in, you can use them as a means of checking and comparing the positions of the features of the actual head you are drawing, making adjustments accordingly.

· · · · · · · · · · Q & A · · · · · · · · · ·

HEAD FROM AN ANGLE

· ·

How can I get the proportions right when the head is viewed from an angle?

One of the most difficult things when drawing a head is to apply the "rules" of proportion if the head is seen in semi-profile, or is tipped back or forward. From these angles, the eyes, nose and mouth may appear compressed together or distorted, because they are seen from a foreshortened viewpoint. Because our mind finds it difficult to accept these distortions, and therefore tries to recreate the head-on measurements, the proportions of the head and the positioning of the features have a tendency to go awry.

Drawing the head from an angle involves careful observation and some precise measuring. As you draw, use your pencil as a tool to measure the distance between, say, the nose and the back of the ear and then compare that with the distance from, say, eyebrow to chin. By constantly measuring and comparing in this way you should arrive at an accurate result. (For more information on measuring by pencil, turn to page 64.)

Eyes in a tilted head
Seen from the front, the head is longer than it is wide, but as it is turned to the side, more of the back of the head is revealed. Whereas, from the front, the eyes are normally about one eye-width apart, from a three-quarter view that distance may vary, and the eyes are noticeably different from each other in size and shape. As you draw, make sure that the slope of the eyes and mouth is consistent with the tilt of the head; a common mistake is to place the eyes level with each other when the head itself is tilted upwards or downwards.

Head down or back
When the head is cast downward or tilted back the features appear compressed towards the top or bottom of the face. Note also how the position of the ear alters, appearing higher than the eyes when the head is tipped down, and lower than the eyes when the head is tipped back.

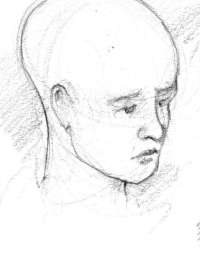

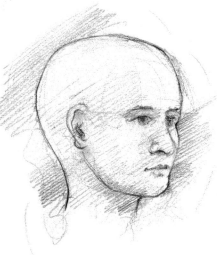

Head Study Kate Adams,
charcoal
This drawing presents a
dramatic study of a
foreshortened head. Notice
how the features appear
compressed towards the top of
the head, and how the curved
shape of the chin is accentuated.

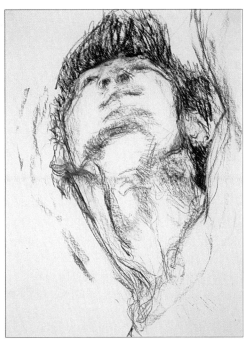

Young Girl Jan Kunz,
watercolour
Although more difficult to draw,
a three quarter turned face can
often make a more expressive
portrait than a face viewed full
on. In this portrait, for example,
light striking the face from an
angle creates interesting
highlights and shadows. These
not only define the modelling of
the features, but also lend life
and atmosphere to the portrait.

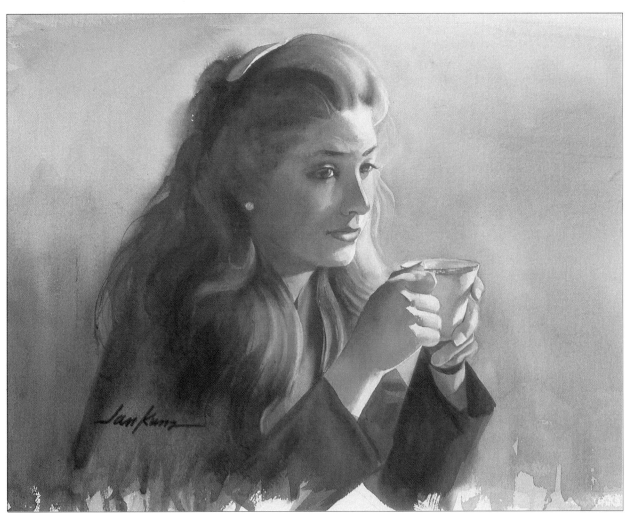

ART SCHOOL

· ·

THE MUSCLES OF THE HEAD AND NECK

Portraiture becomes much easier if you have some under-standing of the muscles that lie beneath the surface of the skin. It is not necessary to have a detailed knowledge of anatomy, but a working knowledge of the muscles of the head and neck, and their effect on the appearance and expression of the sitter, can be a great help.

Facial expressions are formed by the movement of the muscles of the face, the scalp and the front of the neck. Many of these muscles are interconnected: when we laugh, for example, virtually every muscle in the face comes into play.

The muscles around the mouth and eyes are particularly important to the portrait painter. The *orbicularis oris*, which surrounds the mouth, is made up of several small muscles that enter the lips from above and below. The buccinator muscles pass from the sides of the mouth into the cheek. This combination of muscles is responsible for the consider-able mobility of the mouth, which is capable of countless expressions, from the pronounced to the very subtle.

The *orbicularis oculi* muscles surround the eye cavities, allowing the eyes to open and close. Above the eye are the

frontali frontalis occipito muscles, which control the move-ment of the forehead and eyebrows.

In a portrait, the angle of the head and neck can be very expressive of the model's character and mood. It is important to think about the way in which the neck is attached and how its movement affects the positioning of the head. The ability to observe and interpret these movements is vital if you are to create a living likeness of your sitter.

The sternocleidomastoid muscles are the most important muscles of the neck. They pass from behind the ears, converge in the neck to form a pronounced V-shape and are attached to the clavicle and the sternum. They allow the neck and head to bend forward and the head to turn from side to side. These muscles will be apparent in almost all the head movements of your model, particularly when the head is turned to one side.

The effects of the facial and neck muscles can be studied by observing yourself in a mirror. Try out various facial expressions and tilt your head up, down and from side to side. Notice which muscles you use and how they change in appearance as you move.

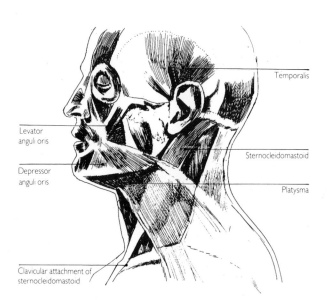

Temporalis

Levator
anguli oris

Depressor
anguli oris

Sternocleidomastoid

Platysma

Clavicular attachment of
sternocleidomastoid

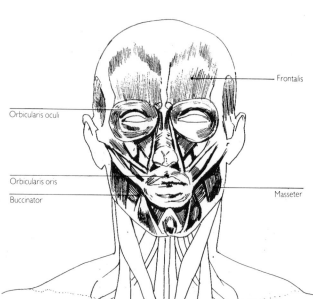

Frontalis

Orbicularis oculi

Orbicularis oris

Buccinator

Masseter

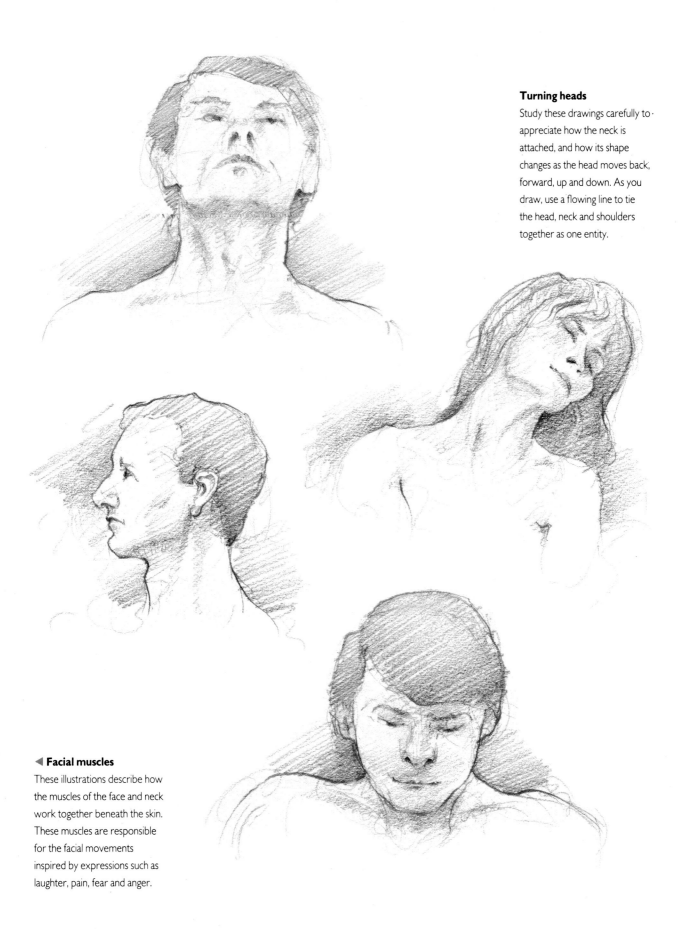

Turning heads
Study these drawings carefully to appreciate how the neck is attached, and how its shape changes as the head moves back, forward, up and down. As you draw, use a flowing line to tie the head, neck and shoulders together as one entity.

◀ **Facial muscles**
These illustrations describe how the muscles of the face and neck work together beneath the skin. These muscles are responsible for the facial movements inspired by expressions such as laughter, pain, fear and anger.

Q & A
FLESH TONES I

Which colours should I mix when painting "white" skin tones?

Asking what colours to use when mixing skin tones is like asking "how long is a piece of string?" There is no single, all-embracing formula for painting skin tones, because they vary enormously, even within the same sex and racial group – and even between one part of the body and another. Skin is also a reflective surface and is therefore influenced by the quality of the prevailing light.

Commercially available flesh tint colours are very useful – for painting clouds at evening. Do not rely on them for painting skin, though, because they are dull, dull, dull! With suitable mixing, you can create hues that are infinitely changeable, enabling you to capture all the warmth and subtlety of human flesh. For example, a suitable mixture for

▼ ▶ Flesh tones

There is no set formula for mixing flesh tones: your best plan is to experiment with different combinations of colour and see which ones work best. Some suggestions are offered here.

gamboge + a touch of madder lake

yellow ochre + madder lake

Portrait of David Lincoln
James Horton, *oil*
The close-up detail, *right*, of the sitter's head shows how the skin tones are executed with large, loaded brushstrokes, creating a series of block-like strokes of colour following and sculpting the forms of the face. The lights in the skin are handled in warm orange-pinks, the darks in cool greens and blues, mixed with white to give a subtle luminosity.

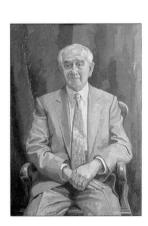

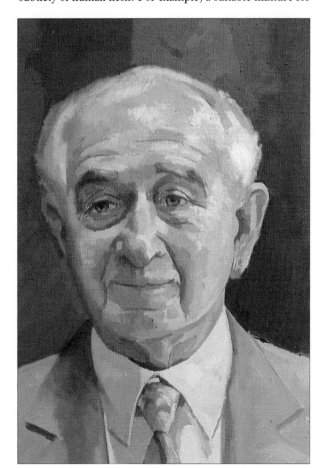

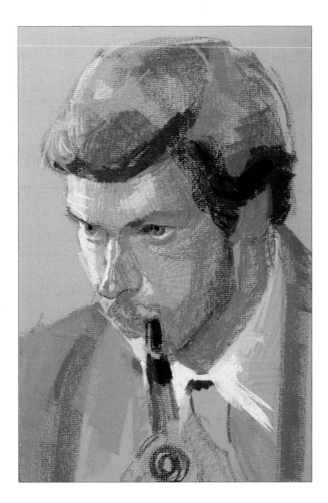

Young Professional

John T Elliot, *oil pastel*
With vigorous, confident strokes
and a very simple palette of
colours, the artist has created a
lively and expressive portrait.
There is virtually no blending
anywhere in the portrait; the
strokes of the pastel crayon
follow the planes of the face
naturally, and the surface of the
paper is often employed as the
middle tone in the face.

yellow ochre + madder lake +
a touch of cobalt blue

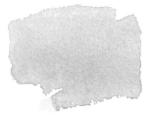

viridian + gamboge + burnt
sienna

yellow ochre + madder lake,
very diluted

gamboge + burnt sienna + a
touch of viridian

"white" skin might comprise roughly equal quantities of white, alizarin crimson and yellow ochre, with a touch of cadmium red. Mixing these colours in different proportions gives you a good base from which to start. Reds, umbers and siennas can be added to warm up the prominent, light-struck areas, while blues, violets and greens can be added in the shadow areas and receding planes.

The colours that you choose to mix will, of course, depend on the particular skin type of your sitter. Decide first whether it is generally a warm ivory colour, pale and sallow, ruddy or olive. Mix a mid-tone accordingly and apply it, well diluted, as a base colour. Paint quickly and freely, wet-in-wet. Working from this base colour, start to place the lightest and darkest tones, and then work on the mid-tones – those transitional areas between light and shadow. Remember that the colours in the sitter's clothing and the background will affect the colours of the flesh tones, so develop these along with the face. As you work, it helps to step back from the painting from time to time to check that the combination of colours and tones is creating the desired effect.

Q & A
FLESH TONES II

Which colours should I mix when painting dark skin tones?

When it comes to painting dark skin tones, you might assume that you would use straightforward mixtures of browns and greys, with a high proportion of black. On the contrary, dark skins can vary enormously in colour, depending on a person's ethnic origin. People of Asian, Latin and Caribbean origin have comparatively warm skin tones, whereas the skins of Africans tend to be darker and cooler, with a violet sheen.

When you are painting a dark-skinned subject, follow the same procedures as when painting a white-skinned subject. First, determine whether his or her complexion tends towards the warm or the cool side. Mix a colour that most closely approximates the overall impression and use it for the initial block-in. After this, establish the lightest and darkest tones before introducing the mid-tones. As a rule, dark skin looks warmest in the shadows and coolest in the highlights, which may have a bluish tinge.

No matter how dark your sitter, resist the temptation to use black in your fleshtone mixtures, as this will kill the

Portrait of Gordon Parks
Douglas Lew, *watercolour*
Dark skins generally have more of a sheen than Caucasian skins, and thus the contrast between the highlights and the darker areas surrounding them can appear quite strong.

Portrait Study David Curtis, *oil*
Avoid using black when painting dark skin tones, as it deadens other colours. Deeper, richer skin tones can be achieved by working with umbers, siennas, ochres, violets and blues. The lights in this model's skin have a bluish tone, which makes for an interesting contrast with the warm brown mid-tones.

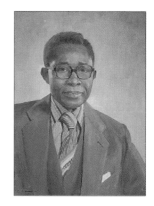

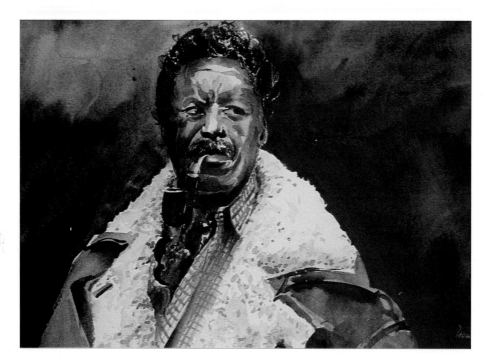

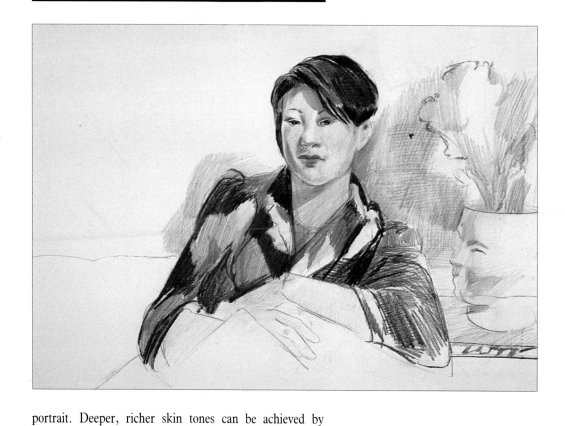

The Chinese Gown John Devane, *coloured pencil*
For this coloured pencil portrait of a Chinese girl, the artist used a selection of colours – dark grey, yellow, red, blue, brown and violet – to build up the subtle colours of the flesh tones, with directional strokes that help to indicate the forms.

portrait. Deeper, richer skin tones can be achieved by working with dark umbers, siennas, ochres, violets and blues. Dark skins generally have more of a sheen to them than Caucasian skins, and thus the contrast between the highlights and the darker areas surrounding them can appear quite strong. Take care, however, not to overplay this contrast – the highlights are probably darker in tone than you think.

Suggested colour mixtures
Below are some suggested colour mixtures for painting dark skin tones.

yellow ochre + burnt sienna

burnt sienna + a touch of cobalt blue

burnt sienna + yellow ochre + a touch of madder lake deep

viridian + yellow ochre + burnt sienna

burnt umber + burnt sienna + Rembrandt blue

burnt sienna + a touch of cobalt blue

burnt umber + Rembrandt blue

burnt umber + a touch of madder lake + Rembrandt blue

·········· Q & A ··········
SKIN: SHADOWS AND HIGHLIGHTS

How do I paint the shadows and highlights on skin?

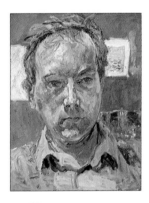

E. W. G. 1988 Susan Wilson, *oil*
Here, the contrast of warm and cool colours in the skin gives a strong impression of the advancing and receding planes of the face.

Highlights and shadows
Below are some suggested colour mixtures for creating cool shadows and warm highlights in the skin.

It is impossible to analyze closely the colour of shadows and highlights on the skin. They are not simply a lightened or darkened version of the basic skin colour, so if you add white to create highlights or black to create shadows, you will find that this is a less than adequate solution.

Highlights and shadows on the skin are fascinating because they often contain quite unexpected colours. If you have the courage to put down the colours you see, rather than those you *expect* to see, you will find that your portraits will come alive. You will notice, for example, that the skin on the prominent, light-struck parts, such as the forehead, nose, cheeks and chin, may contain warm reds and yellows, while the receding planes, such as the eye sockets, the shadow side of the nose and the area under the chin, contain cool blues, browns, violets and green-greys. However, this is by no means an absolute rule; skin is basically warm in colour, so a shadow cast by one area of skin on to another will retain a degree of warmth. You will notice this particularly in folds in the skin, on wrinkles, and in the shadow under the lower lip.

The use of warm and cool colours in skin tones serves another important purpose: because warm colours appear to advance and cool colours to recede, you can use warm/cool contrasts to model the advancing and receding planes of the face and figure, thereby giving your portraits a strong sense of three-dimensional form and solidity.

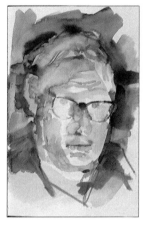

Sketchbook page
John Lidzey, *watercolour*
The beauty of watercolour is that you can use the white of the paper to create luminous highlights in the skin. In this portrait study, overlaid washes of warm browns and cool blues interact on the paper to define the structure of the head.

alizarin + cobalt blue + a touch of burnt sienna

yellow ochre + burnt sienna + a touch of cobalt blue

burnt sienna + yellow ochre + a touch of cadmium red light

yellow ochre + a touch of burnt sienna + cadmium red

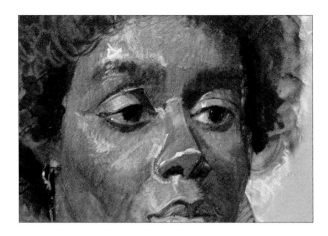

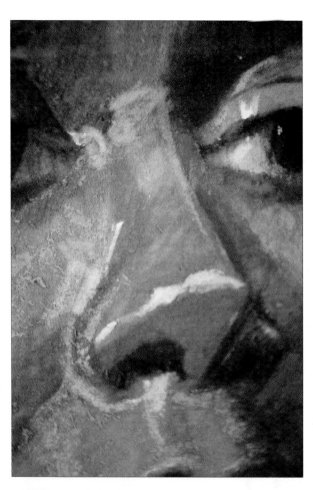

Model John T Elliot, *pastel*
In certain situations you will
discover areas of warm
reflected light, not only in the
highlights, but also within the
shadows. By observing and
depicting these, you will improve
enormously the luminosity of
your skin tones.

▶ **Highlights on the nose**
This detail from the portrait
shows how the artist has
used the point of his pastel sticks
to create crisp highlights on the
nose, contrasting with the softly
blended tones beneath.

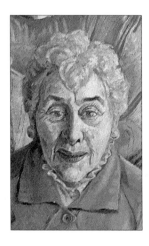

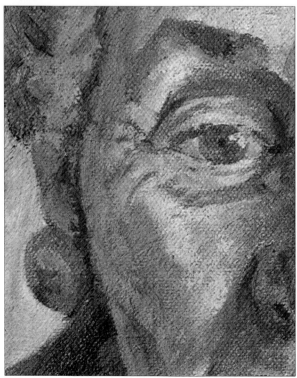

Older woman Rosalind
Cuthbert, *oil*
When painting wrinkles in skin,
don't make them too dark or
too cold in colour. In the detail,
right, the wrinkles around the
eyes are of a fairly warm
pinkish-brown. Another tip is to
avoid painting wrinkles with a
stiff, uniform line. Paint them just
a tone or so darker than the
surrounding skin and lightly
touch them in, painting against
the line and not along it.

Q & A
SKIN TEXTURE

How do I convey the texture of skin?

How you render the texture of skin will depend on your own painting style and your chosen medium. A look at some of the portraits of the great masters will reveal a huge and diverse range of techniques and approaches with which you might like to experiment. Rubens, for example, underpainted with thin paint in tones of umber, then overpainted with strokes of colour which were placed side by side and were only lightly blended. Renoir's luminous, pearly skin tones were derived from the use of transparent colour brushed thinly over a pale ground that glows through the paint layers. Gauguin's figures, with their smooth planes of subtly modulated colour, have the monumental appearance of sculpture.

There are a number of ways of applying paint to interpret the unique texture of skin. Some artists like to build up the colour with transparent glazes and scumbles to give sheen and translucency to the flesh. Others prefer to work freely in the *alla prima* style, working wet-in-wet, slurring the colours into each other and leaving them partially mixed to achieve subtle gradations of tone and colour.

Careworn face Rosalind Cuthbert
The lines and creases in a well-worn face present the artist with an excellent subject for the study of form, texture and colour in the skin. Here, Cuthbert was fascinated by the topography of the model's face, and gives it strong emphasis by allowing the face almost to fill the entire picture. Strong directional lighting heightens the forms of the deep creases and loose folds in the skin, which are strongly modelled to give a vigorous, sculptural quality to the painting.

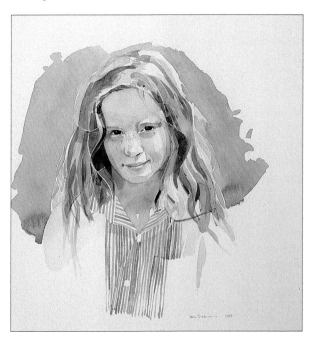

Young Girl Ian Sidaway, *watercolour*
Because of its transparency, watercolour is the ideal medium for painting young skin. The secret is to use thin, delicate washes, allowing light to reflect back from the paper beneath and create an impression of the skin's natural luminosity.

Eleanor Paul Dawson, *watercolour, acrylic and gouache*
With careful attention to detail, Dawson has created a portrait with a serene and timeless quality. The smoothness of the model's skin (see detail, *below*) was achieved with a technique not unlike tempera painting. First the light side of the face was preserved with masking fluid, then the darks and mid-tones were laid in with watercolour washes. When these were dry, the modelling was completed with a painstaking build-up of tiny strokes in watercolour. Finally, the tones were modified with extremely thin, delicate washes of acrylic paint so as not to disturb the colours beneath. With the masking fluid removed, the white paper provides more luminous highlights than could be achieved with white paint.

Face Study John T Elliot, *pastel*
In this portrait, the artist allows the surface tone of the paper to show through the overlaid colours, lending luminosity to the skin tones. Broken lines of pastel are used both to chisel out the planes of the face and to indicate the rugged texture of the model's skin.

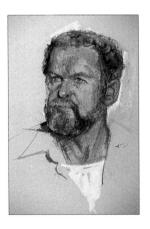

Look for the variety of textures in the skin on different parts of the body: thin, stretched skin, as found on the nose and forehead, is smooth and reflective, while loose, wrinkled skin is plumper and more matt. If you fail to convey these changes in texture, the skin takes on an unreal, rubbery appearance.

It is vitally important to keep your colours clear and unsullied if you wish to convey the subtlety and translucency of human skin. Here are some guidelines to help you:

● Keep your equipment clean. Rinse your brushes out frequently and change your dipper or water jar when it begins to turn muddy.

● Use a palette with a large mixing area that will not become clogged with colour too quickly – and never mix a new batch of colour on top of an old one.

● Arrange your palette systematically. You might want to arrange the colours in sequence from warm to cool, or keep the whites, yellows and earths near each other because they are the ones most often used in mixtures.

● Lay out and mix sufficient paint so that you will not be hampered by continually having to stop and mix afresh.

● Use no more than three or four colours in any one mixture, otherwise they begin to turn muddy. For the same reason, mix your colours on the palette, not on the support.

Q & A
EYES I

How can I make the eyes in my portraits look more realistic?

With good reason, the eyes have been called the "mirror of the soul"; more than any other facial feature, they convey a person's mood, temperament and character. To draw and paint eyes convincingly, it helps if you understand their underlying structure. Without this knowledge it is all too easy to rely on a preconceived formula – generally an almond-shaped outline with a circle in the middle – which lacks any sense of form or expression.

Perhaps the most common feature of beginners' portraits is "the manic stare", in which the poor sitter's eyes seem to be bulging out of their sockets. This is due to two mistakes, the first being to place the iris in the dead centre of the eye,

Conveying the shape
Make sketches of individual eyes, concentrating on describing the spherical nature of the eye (think of the eye as a ball resting inside the circular cup of the eye socket). Note how the eyelids change shape according to the direction of the gaze.

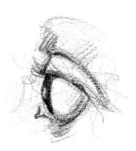

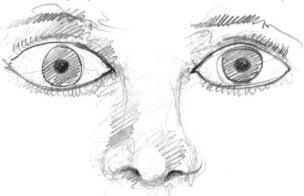

Dead eyes
Some common mistakes made by beginners: the iris is centred in the eyeball, giving a "staring" appearance; the hard outline and lack of shading makes the eyes look flat and cartoon-like; and the eyelashes appear clumsy and unnatural.

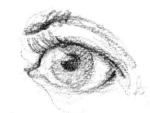

with white showing all around it. In fact, the upper lid covers part of the iris, and quite often the lower lid does the same. It is also worth noting that the upper and lower lids are not identical in shape: the lower lid is much flatter.

Another common mistake is neglecting to observe and record the highlights and shadows on the whites of the eyes, which help to convey their spherical nature. Circles of pure, flat white look more like dinner plates than eyes, and give

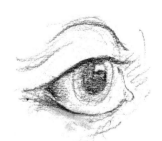

Eyelids
Here, the artist has observed how the iris is partly covered by the eyelids. Sensitive shading conveys the spherical nature of the eyeballs and the eyelashes are indicated only by a slightly heavier line.

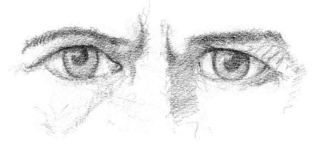

▶ Individuality

Practise drawing eyes, watching out for individual differences between the eyes of men, women, children and older people. In all cases, note that the upper eyelid covers around one third of the iris; the lower lid usually, though not always, touches the iris.

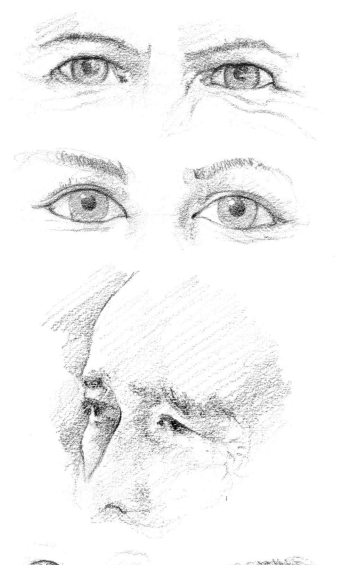

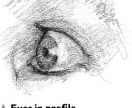

▲ Eyes in profile

Seen in profile, the eyes have a recessed appearance. The eyeball sits inside the lid and is therefore set back from its surface. The curvature of the eyeball is also more pronounced, and the rim of the lower lid is visible.

◀ The surrounding skin

The older we get, the more the skin beneath the eyebrow sags, giving the eyes a tired look.

▲ Positioning eyes

When drawing a head in profile, carefully observe the position of the eye. You may be tempted to place it too high up or too far back from the nose.

▼ Eyes at an angle

When the head is turned at an angle to the viewer, the eyes may appear different in size and shape.

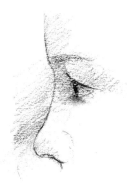

Children

Children's eyes are larger, rounder and clearer than adults' eyes, and bigger in proportion to the face.

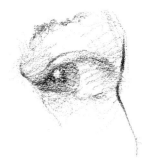

the sitter a vacant look. If you look carefully at the eye, you will see that the eyelid casts a shadow on the eyeball. Indeed, depending on the light, the whites of the eyes may not appear white at all, but a bluish grey.

The most important thing of all is to remember that you are not simply drawing a pair of eyes – you are drawing a pair of eyes that are unique to one individual, and accuracy is important if you are to achieve a convincing likeness. As you draw, observe the sitter's eyes in detail. Are the eyelids narrow or hooded? What about the shape and thickness of the eyebrows and their distance from the eyes? It is easy to draw one eye either larger or smaller, or higher or lower than the other; so check your drawing before starting to paint. (A good tip is to hold your drawing up to a mirror – any faults will show up immediately.)

Do not forget to look at the eyes in the context of the face as a whole, constantly measuring and comparing the size and position of the eyes in relation to the other features.

Painting eyes

As when painting the mouth, it is important to work continually back and forth between the eye and the surrounding skin, so that the eye becomes an integral part of the face and does not appear "stuck on". In this watercolour demonstration, David Curtis models the eye and surrounding area with washes and glazes that are both crisp and hazy, so that the eyes have definition without looking static.

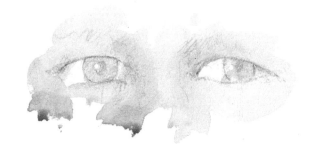

I The eyes are lightly sketched in pencil. The highlights on the pupils are touched in with masking fluid, then a dilute wash of raw sienna and light red is passed over the whole area of the drawing, leaving the left-hand corners of the eyes white.

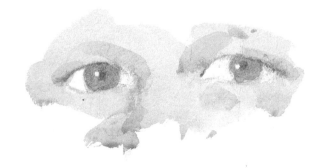

2 With loose washes of raw sienna, light red and a touch of cerulean, the shadows around the eyes and on the side of the nose are indicated. The irises are painted with burnt sienna and French ultramarine.

3 The flesh tones are now strengthened with further washes, using the same mixture as before. The artist uses successive washes of colour, wet-on-dry, to model the contours of the nose and eye area.

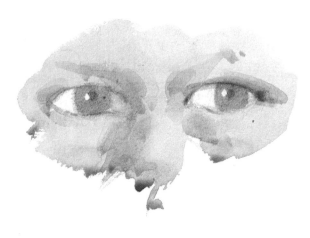

4 Finally, the cooler, darker shadows are strengthened with a mixture of raw sienna and cerulean. Using a dark mixture of burnt sienna and French ultramarine, the pupils are "dropped" in with the tip of the brush. The "white" of the eyeballs is toned down at the inner corners with a touch of pale cerulean, to emphasize the curve of the eyeballs. When the paint is dry the deeper shadows are re-emphasized by shading with a 4B pencil, and the masking fluid is removed from the highlights on the pupils.

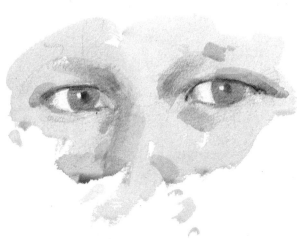

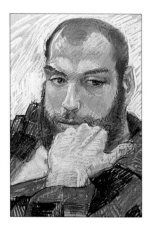

▲ **Lumberjack** John T Elliot, *pastel (detail)*

The eyes are the feature to which we are immediately drawn in this portrait. The sitter's lowered gaze, directed at a point outside our vision, gives the painting a mood of reflective introspection. Another point worth noting here is that it is rare for a person to have both eyes exactly the same shape.

The Actress John T Elliot, *pastel (detail)*

The surface of the eyeball is highly reflective; as light falls on it, a highlight appears on the iris, giving the eyes their lively quality. Notice here how the "whites" of the eyes have been toned down to a bluish grey; against this the true whites of the highlights really sparkle.

▲ **Minimal effects**

This close-up detail demonstrates that you do not have to be absolutely precise when drawing the eyes. A certain amount of "abbreviation", a "lost and found" quality in the drawing, is desirable in keeping the eyes looking alive. Here, for example, the pupils are not perfect black circles, just marks quickly dashed in with the point of the pastel stick, yet they still look convincing.

EYES II

My sitter wears spectacles – how do I paint them?

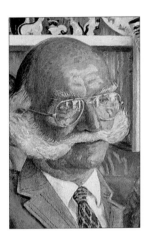

▲ Portrait of Ray Trapnell
Rosalind Cuthbert, *oil on canvas*
(detail)
Although the sitter's spectacles
and resplendent walrus
moustache are dominant
features, the artist has not
allowed them to overwhelm the
painting to the detriment of the
total effect. In painting the
reflections in the spectacle
lenses, she has used a minimum
of brushstrokes to gain the
desired effect. Note also that
only one or two highlights are
painted white; the rest are toned
down.

If your sitter habitually wears spectacles, it is best to paint
him or her with them on, since they are an integral part of
that person's image. You can adopt one of two approaches
when painting spectacles: either request the sitter to remove
his glasses and then replace them once you have completed
painting his eyes, or paint him wearing his glasses from the
beginning. Most artists favour the latter approach, because it
enables them to incorporate the slight distortions created by
the glasses and the shadows that they cast.

Painting spectacles requires a sureness of touch. The trick
is to suggest their presence rather than to reproduce them in
precise detail. Choose just a few selected lines, tones and
reflections that shape and define the glasses and paint these
with the absolute minimum of brushstrokes. When the
portrait is complete, the glasses will appear natural and
correct without attracting too much attention. If, on the
other hand, you include every line, shadow and highlight,
the glasses will take on too much prominence, obscuring the
features underneath and appearing clumsy.

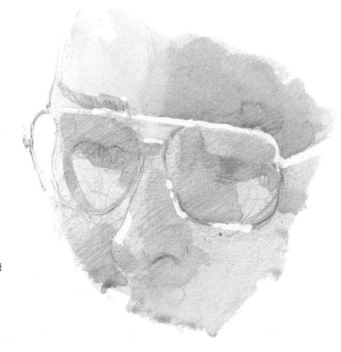

A face with spectacles
In a sense, painting a face with
spectacles is easier than painting
a face without them; the outline
of the spectacle frames isolates
individual features and provides
you with a datum – a fixed
starting point – for positioning
the eyes, eyebrows, nose and
ears. Here, David Curtis
demonstrates how he paints a
model wearing spectacles,
viewed in semi-profile, in
watercolour.

I The artist begins with a light
underdrawing in pencil,
modelling the planes of the face
with hatched lines. The shapes of
the spectacle lenses must be
drawn carefully, taking into
account the foreshortened
perspective caused by the
oblique angle of the head.
Masking fluid is applied to the
highlighted areas to retain the
white of the paper. A pale mix
of raw sienna and light red is
used for the skin tones, with the
addition of cadmium yellow in
the light areas and cerulean in
the shadow areas.

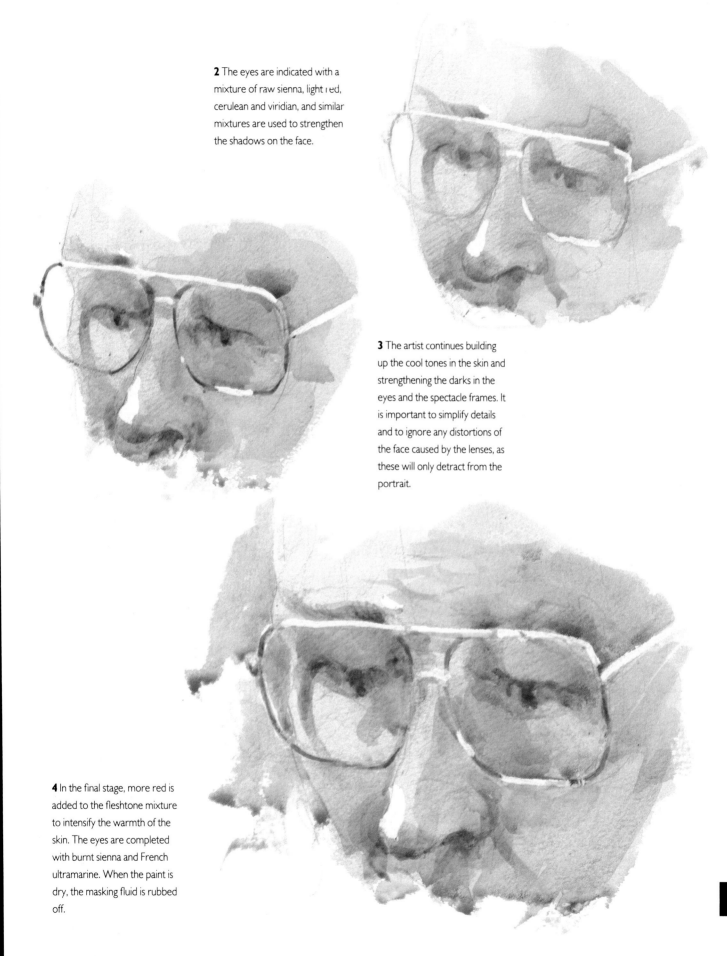

2 The eyes are indicated with a mixture of raw sienna, light red, cerulean and viridian, and similar mixtures are used to strengthen the shadows on the face.

3 The artist continues building up the cool tones in the skin and strengthening the darks in the eyes and the spectacle frames. It is important to simplify details and to ignore any distortions of the face caused by the lenses, as these will only detract from the portrait.

4 In the final stage, more red is added to the fleshtone mixture to intensify the warmth of the skin. The eyes are completed with burnt sienna and French ultramarine. When the paint is dry, the masking fluid is rubbed off.

········· Q & A ···········

MOUTHS I

·······································

Why are mouths so difficult to paint?

I think it may have been Whistler who said, "a portrait is a painting in which there is something wrong with the mouth." This statement has raised many a rueful smile, since mouths are notoriously difficult to get right. The problem is that mouths are capable of an infinite range of expressions, many of them extremely subtle and difficult to capture convincingly in paint. Yet the mouth plays such a vital part in capturing an individual's likeness, as well as expressing personality and temperament, that it is essential to get it right.

All mouths have roughly the same physiological structure, determined by the underlying bones and muscles, yet no two mouths are exactly the same. The point where the mouth falls between the nose and chin; the width of the mouth in relation to the width of the face; the colour of the lips, and the size of the upper lip compared to the lower lip, all of these are unique to each individual. Recognizing and recording such distinctions, which are often extremely subtle, calls for close observation and sensitive rendering. But before you can render an individual mouth you must learn how to paint and draw mouths in general, and you need to understand their anatomical structure. The following general principles will help you to render mouths accurately and realistically, so that you will then find it easier to record the exact likeness of a particular mouth.

Modelling the mouth
Below centre A common mistake when drawing mouths is to begin by drawing the final outline of the lips and then "filling it in". This linear approach gives the lips a flat, pasted-on appearance and destroys the impression of softness and mobility.

Shading the mouth
"Feel out" the shape of the mouth with light, sketchy strokes. Add deep shadows between and under the lips, then shade in the flat areas that face away from the light source. Allow the tones of the lips to blend into the surrounding skin. In pencil and watercolour, the highlights are provided by the white of the paper.

Foreshortened mouth
When viewed in semi-profile, the mouth is foreshortened. Observe carefully the shapes of the upper and lower lips and how they curve around the dental arch. Make sure that the "Cupid's bow" in the centre of the upper lip aligns correctly under the nostrils.

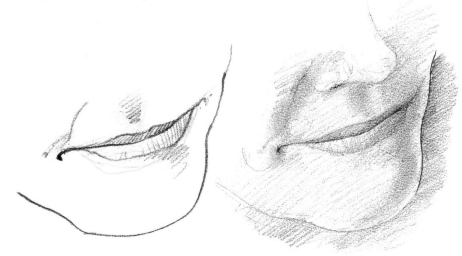

▼ Male mouth

Male lips are usually thinner, flatter and more elongated than those of females. The line where the lips meet is sharper, and the plane changes in the upper and lower lips are more abrupt and angular.

Children's mouths

Children's mouths are small and soft, and the lips have more bulge and curvature than those of an adult. The corners are uplifted and the "Cupid's bow" is very pronounced in younger children.

▲ Female mouth

The female mouth is generally softer, fuller and has a more clearly defined outline than the male mouth. The planes of the upper and lower lips are gently curved.

The upper lip

The upper lip is thinner and more defined than the lower lip.

Corner shadows

There may be small shadows at the corners of the mouth, which may be soft or hard, depending on the person's age and the expression of the mouth.

The lower lip

The lower lip is fuller and softer than the upper lip, especially in women and children.

Contouring

Sometimes a pale contour is visible along the line of the upper lip.

Light from above

In light coming from above or in front, the upper lip is in shadow, and the darkest part of the shadow is where the two lips meet.

Catching the light

The colour of the lower lip is often "bleached" where it catches the light.

Shadows

The lower lip is defined by the shadow underneath it, formed by the little groove between mouth and chin. This shadow is darkest beneath the centre of the lower lip, fading as it moves towards the corners.

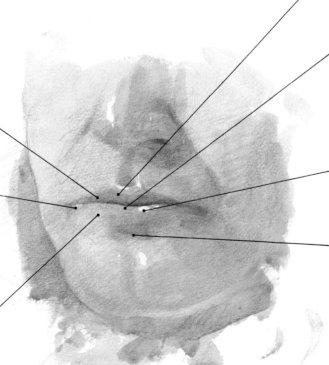

Nina James Horton, *oil on canvas*

The mouth is important in portraying mood, character and age; in this portrait of a young woman, the corners of the mouth are uplifted and the transition from mouth to cheek is smooth. Use the corners of the mouth to help integrate the lips into the face and prevent them looking "pasted on". Do not overstate them, though – keep them soft and understated.

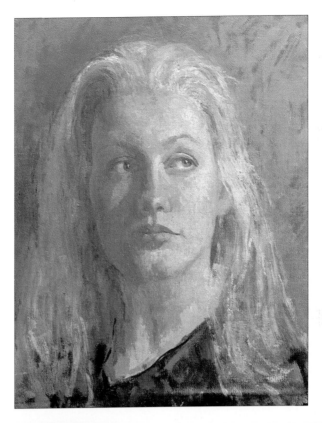

▼ **Conveying mobility**

This detail of the mouth shows how the artist has not painted it with line, but with patches of colour against the line. The treatment of edges – some sharply defined, some softly blended into the surrounding skin – gives a feeling of mobility to the mouth.

Painting the lower face

The mouth should not be painted in isolation; the muscles underlying the mouth, cheeks and chin are interconnected, so it follows that the whole of the lower face should be painted as one entity. In this sequence, David Curtis demonstrates how to build up the forms of the mouth and surrounding area with overlaid washes of colour.

◀ **1** An outline of the mouth and nose is sketched in pencil. After touching in the highlight points with masking fluid to preserve the white of the paper, the mouth and surrounding area are covered with a light wash of raw sienna and light red.

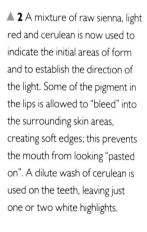

▲ **2** A mixture of raw sienna, light red and cerulean is now used to indicate the initial areas of form and to establish the direction of the light. Some of the pigment in the lips is allowed to "bleed" into the surrounding skin areas, creating soft edges; this prevents the mouth from looking "pasted on". A dilute wash of cerulean is used on the teeth, leaving just one or two white highlights.

▶ **3** The painting is allowed to dry before the mid-tone areas are built up with the same mixture as before. Notice the subtle colour of the lips; it is not much stronger than the colour of the surrounding skin.

◀ **4** A stronger wash, containing a greater proportion of cerulean, is used to re-emphasize the darker tonal areas – the nostrils, the shadow beneath the lower lip and the shadow side of the corner of the mouth. By working loosely and building up his washes gradually, the artist strives to show how the mouth forms flow out of, and into, the underlying facial forms.

33

MOUTHS II

How do I render a smiling mouth?

A smiling mouth is more difficult to paint than a mouth in repose. Unless skilfully handled, the smile can look false and pasted on, as if the sitter were modelling for a toothpaste advertisement.

The essential thing to remember is that we smile not just with our mouth, but with our entire face. As the lips push sideways the cheeks are pushed upwards and crease just beneath the eyes, causing the shape of the eyes to alter. Also, particularly in older people, lines and creases – laughter lines – form around the mouth and eyes.

It would obviously be difficult for a sitter to hold a smiling pose for a long period without the smile becoming somewhat strained and fixed. You may prefer to take photographs of the sitter and refer to these while painting.

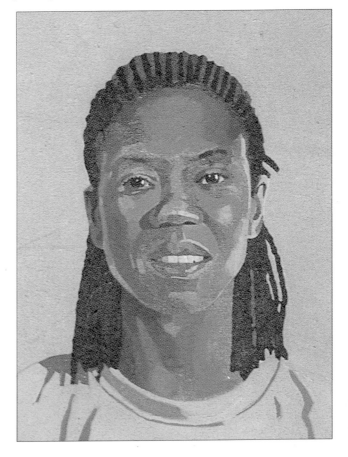

Aleta Ian Sidaway, *oil on canvas*
In this portrait the sitter's smile is enough to animate the face without appearing too exaggerated. Notice how just one or two small white highlights are sufficient to convey the gleam of the teeth; overall, the teeth are fairly low in tone.

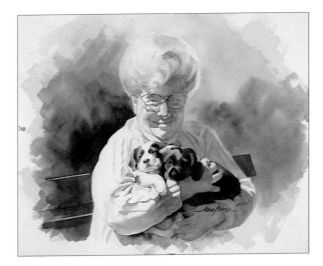

Puppy Love Jan Kunz, *watercolour*
The danger with smiling portraits is that they can appear fixed and somewhat wearing on the eye. Not so with Jan Kunz's portrait of a shyly grinning lady with an armful of puppies. The mouth is not overstated, yet we can almost hear the sitter chuckling with pleasure; it is not only her mouth that is smiling: her cheeks are pushed upwards, narrowing her eyes. The picture emanates warmth and life.

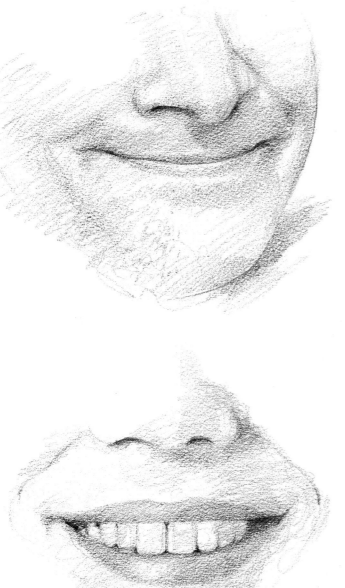

A closed smile

In a closed mouth, smiling lips become narrow and stretched. The line where the lips meet turns up very slightly at the corners, creating small patches of shadow on the surrounding flesh.

Stretched lips

As the lips are stretched out, the shadow beneath the lower lip flattens out and becomes lighter in tone.

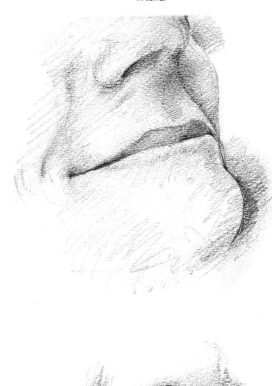

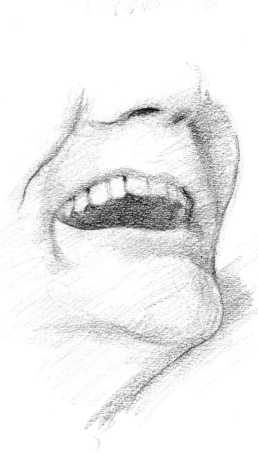

Tooth tone and shape

Observe carefully the tone of the teeth – they are darker than you might assume, particularly where they curve away at the corners of the mouth. The shapes of the teeth are most effectively represented using light and shade, rather than drawing a line between each individual tooth.

An open smile

In a fully open, smiling mouth, the upper lip flattens out and the corners of the lower lip curve upwards. The cheeks are pushed outwards, and folds of flesh may form around the mouth, particularly in more mature people.

Q & A
EARS AND NOSES

I find ears and noses difficult. Any tips?

It is little wonder that noses and ears are often the butt of jokes. When you analyze them, you wonder who could have designed such weird-looking objects. For this same reason, noses and ears are often neglected in amateur portraits; the artist resorts to a few quick squiggles in the fond hope that this will fool somebody, and hastily moves on to the more interesting bits.

In drawing and painting noses, beginners often make the same mistake that they do with mouths: they use a linear, rather than a tonal approach, and this results in a flat, two-dimensional effect. The nose protrudes from the face, but it has no definite outline. To give it form and three-dimensionality, we must observe the shadows and highlights on its surface, and also the shadow that it casts on the face. All of this becomes much easier if the face is illuminated from one side, or from a three-quarter angle, because side-lighting creates more strongly defined shadows and highlights.

Generally, the bridge and the fleshy tip of the nose are the most strongly highlighted, while the outer "wings" are slightly in shadow, and the darkest shadow is under the base. This is not always the case, however: under certain

Drawing the nose
This sequence of drawings shows how to build up the chiselled forms of the nose with hatched strokes, working progressively from the lightest tones to the darkest. The white of the paper effectively provides the highlights.

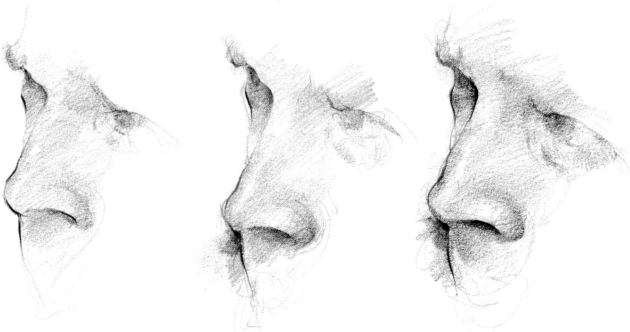

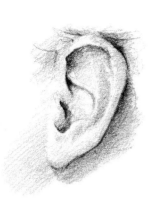

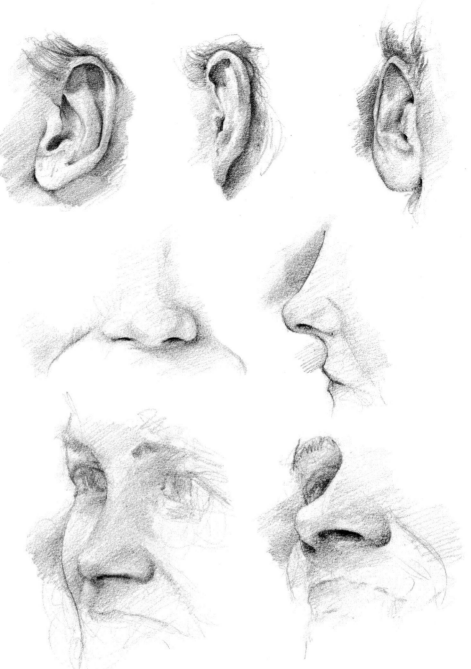

Form of the ear

Practise drawing ears from several viewpoints between side-view and front-view. These are the views with which you will most often be presented in portraiture. Try to indicate the forms as simply as possible, muting the planes so that they flow naturally into each other.

Form of the nose

Viewed from in front, below and to the side, the form of the nose is basically triangular. The visibility of the nostrils depends both on the projection of the tip of the nose and on the tilt of the head.

lighting conditions the bridge of the nose may be in shadow while the wings are highlighted. It is easier to make these observations and assess the differing tones more clearly if you half-close your eyes. You will also find that if you study the outline of the shadow cast by the nose, this will help you to define its shape.

As you paint, blend the tones into each other wet-in-wet, and try to get a sense of the skin of the nose emerging from the cheeks and stretching across the bony bridge.

When drawing and painting the ear, again the trick is to convey an impression of the ear emerging from the skull, rather than being glued on. As with the nose, close

observation of light and the shapes of shadows makes an essential contribution to success.

Although in most portraits the ears are barely seen, it is important to understand their structure so that you can draw them convincingly. You may get confused at first by all the whorls and curves of the ear, but frequent sketching practice will soon familiarize you with its form. Generally, it is best to paint ears as simply as possible, avoiding overstatement. Ask friends or family to "lend you an ear" to draw while they are reading or watching television. Sketch the ears from various angles, and note the differences between the ears of men, women, children and babies.

Media Journalist John T Elliot, *oil pastel*

This portrait study evolves out of densely scribbled pastel strokes, in which the colours are played over a dark-toned paper that serves as the basis for the colour of the hair, beard and jacket. Both the technical approach and the strong colour contrasts are designed to give character to the portrait. Although loosely worked, the head is solidly constructed. Note how the nose throws a shadow across to the lips, connecting with the shadow side of the face. The ears are a warm pink where the light shines through them.

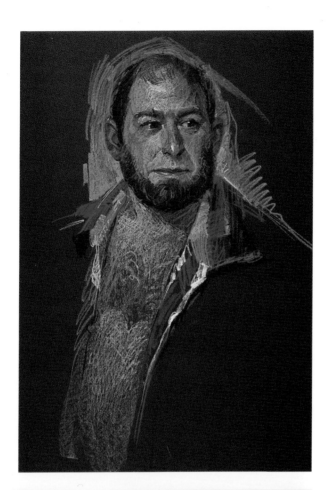

▶ **Study for Portrait of Simon Poli** Alison Watt, *oil*

In contrast to Elliot's portrait, the forms are here reduced to smooth planes of subtly modulated hue and tone, which give the appearance almost of sculpture. The three-quarter angle of the head allows us to study closely the modelling of the nose and ear, both of which are rendered quite simply, yet without any loss of form. The highlights on the nose, particularly at the tip, are important in suggesting its advancing planes. Those parts where the ear joins the head are softly blended, so that they emerge as part of the head and not as some separate entity.

◀ **Surface texture**

This detail from the portrait above reveals the range of marks and the variety of colours that Elliot uses to build up a rich surface texture. Applying strokes of pure colour in different directions creates an optical mixture where one colour overlaps another. From a distance, the colours appear to merge, giving a richer surface quality than can be achieved with flat areas of colour.

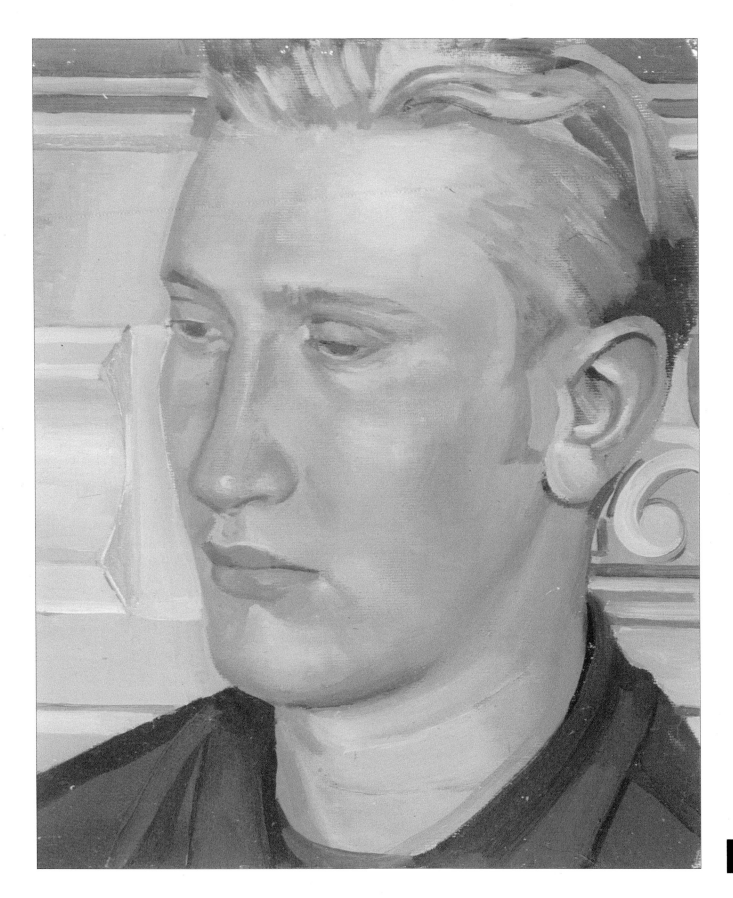

TECHNIQUES FOR PAINTING HAIR

What techniques should I use for painting and drawing hair?

Art Student John T Elliot, *pastel*
In this delicately rendered portrait, John T Elliot has observed and recorded the subtle nuances of colour in the hair. The artist blocked in his colours – browns, greys and greens – and then softly blended them together to capture the smooth, glossy texture of the hair, which reflects a lot of light.

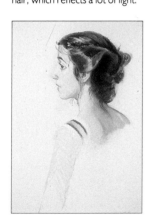

Some amateur painters have difficulty in expressing the softness and sense of movement of hair in their paintings and drawings. Often, the hair is rendered too tightly and with too little variety of colour or light and shade, with the result that the unfortunate sitter appears to be wearing a rather dubious wig!

The secret of rendering hair is not to overstate it, but to paint it as loosely and simply as possible. Start with the broad masses and gradually work up to the finer details. Roughly outline the overall shape of the hair first, using very light, sketchy strokes. Then start to subdivide the hair into areas of light and shadow, blocking in the shadows with broad strokes or washes. Having established the overall shape and mass, use a few judicious lines and strokes to indicate the direction in which the hair curls or falls. Always use a light, sensitive touch, making feathery strokes that move in the direction in which the hair is falling and which build up form and texture gradually, rather than starting with a tightly drawn outline.

As when painting skin, the best way to convey the softness of hair is to keep the tonal masses strong and simple, bearing in mind the old dictum, "less says more". Work wet-in-wet, so that the tones and colours merge into each other with no hard edges. If you are using watercolours, you could alternatively work wet-over-dry, systematically building up from the lightest to the darkest tones with a series of transparent washes.

Hair is not one solid mass of colour, but contains many subtle tints and shades. You may see traces of blue and brown in black hair, honey and red in brown hair, and brown, gold and grey in blond hair. Remember also that the hair's colour may be influenced by the colour of the prevailing light. For a natural effect, try to harmonize the hair colouring with that of the skin by introducing into the hair some of the colours used in the fleshtone mixtures.

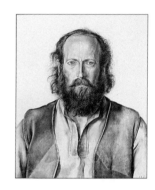

Portrait de l'éthnographe L. Abramian Rudolph Katchaturian, *sepia on Levkas*
In this portrait, the smooth texture of the hatched lines corresponds to the texture of the model's fine hair. Careful control of the density of the strokes creates a range of tones from dark to light that describe the form of the hair.

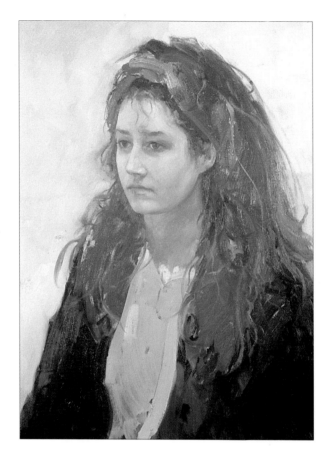

Tracy with a Red Headscarf
David Curtis, *oil*
Remember that hair has body, motion and a life of its own. Let your brush strokes move freely to suggest liveliness and immediacy. Here David Curtis has used sweeping strokes to paint the sitter's tumbling mane of hair. Note how the colour has been softly blended at the hairline and around the outer edges of the hair to give a soft, natural effect.

The secret of rendering hair is not to overstate it, but to paint it as loosely and simply as possible.

Finally, one very important point: hair (and this includes beards, moustaches and eyebrows) should always be painted as an extension of the skin, not as a separate entity. To avoid an abrupt transition from hair to skin – the wig effect – run some of the skin colour into the hairline to soften the division between hair and face, then loosely fuse the two colours together where they meet, either with a brush or with your fingertip. For best results, work the lighter colour into the darker one.

Colour mixes for hair Below are some suggested colour mixtures for painting hair.

1 Black hair Use alizarin crimson, light red and a touch of ivory black, or try Prussian blue glazed over with a mixture of ultramarine and burnt umber.

2 Brown hair Try light red with a touch of ivory black, warmed with cadmium red.

3 Blonde hair Mix yellow ochre and white, with touches of Naples yellow for the highlights, – for reddish blondes – try burnt sienna or light red.

4 Red hair Use yellow ochre, white and cadmium red or light red, with burnt sienna added to the dark areas.

41

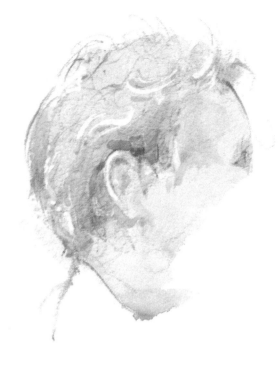

Masking highlights
When painting watercolour portraits, masking fluid is useful for retaining small areas of white paper that will serve as highlights in the hair.

Blonde highlights
Blonde and light-coloured hair can be painted with overlaid washes of burnt sienna or ochre. Masking fluid is used here for the wisps of hair which appear "bleached" by the light.

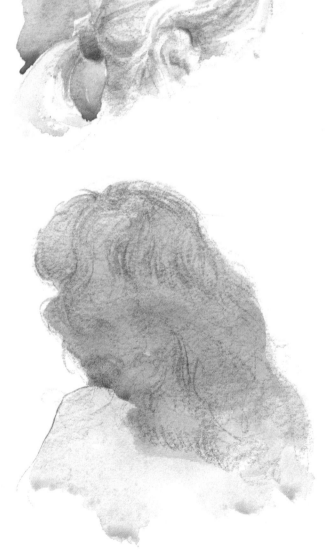

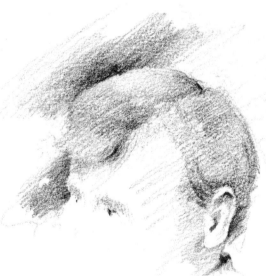

Shading and hatching
Pencil shading and hatching are used here to indicate the volume of the hair with a series of smooth planes.

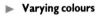 **Varying colours**
When painting hair, introduce a variety of colours, and let your washes and glazes interact to give form while retaining softness and movement.

Alexandra Ian Sidaway,
watercolour
Here, the artist has capitalized
on watercolour's transparent
qualities in capturing the delicacy
of a child's hair. The essence of
Sidaway's technique is to keep
the tonal masses strong and
simple. Working from light to
dark, he builds up the forms of
the hair mass with successive
washes that give a fresh,
translucent appearance.

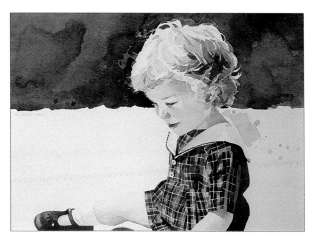

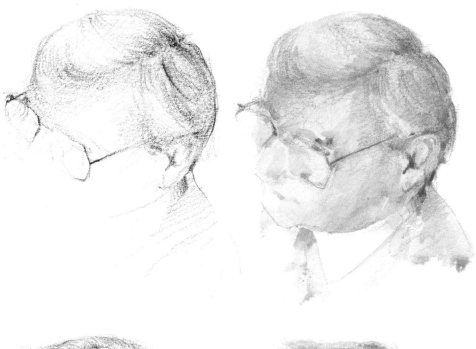

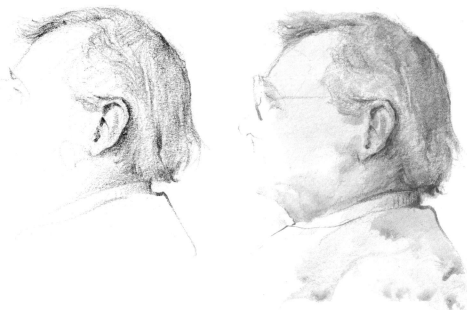

Head studies

It can be instructive to make
studies of heads viewed from
different angles to familiarize
yourself with the texture, form,
colour and direction of growth
of the hair. Note the direction in
which the light falls on the head
– normally more light is
reflected on top of the head
than at the sides. A common
error is to draw the hair too
tightly and rigidly, giving it a hard,
unnatural appearance. Practise
sensitive line or brush work to
soften the outline of the hair and
suggest air and light around the
head.

43

·········· Q & A ··········
CAPTURING A LIKENESS

My portrait doesn't quite capture the character of the sitter. Where did I go wrong?

Expressions

To familiarize yourself with the range of human facial expressions, make sketches from live models, or from photographs in magazines and newspapers.

Duke Douglas Lew, *watercolour*
In a sense, a good portrait contains an element of caricature. In order to inject life into your portrayal, you need to get to the essence of your subject, to seek out and emphasize those distinguishing features and mannerisms that make this person unique. Here, Douglas Lew has captured John Wayne as we all know and love him – in "cowboy" mode.

Capturing a likeness of your subject is not just a question of making an accurate reproduction of the physical features. It is also about getting under the skin of the person and revealing something about their personality and their inner feelings. When these two aspects – sound observational drawing and an emotional empathy with the subject – work in tandem, the result is a portrait that is alive and meaningful rather than merely competent.

Assessing personality will present few problems if your sitter is someone you know well. But even if your sitter is a total stranger, you will find that most people reveal something of their personality as soon as they enter a room. The way in which a person dresses and speaks, and the gestures and mannerisms that they habitually adopt, all give important clues to personality.

Before you even put pencil to paper, try to absorb a general impression of your subject. Is the person confident and outgoing, or shy and sensitive? Does the face have the innocence and bloom of youth, or is it etched with the lines that come from decades of laughter and sadness? Look out for repeated gestures and mannerisms, the tilt of the head, the set of the jaw, the pose adopted when sitting or standing. All of these things are part of an individual's "personal imprint", and every bit as important as their physical features in distinguishing them from other individuals.

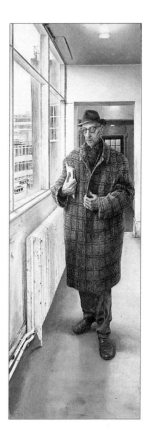

Cecil Collins at the Central School of Art Rosalind Cuthbert, *oil*
In this portrait, the artist uses pose, gesture, composition, colour, background, and even the tall, narrow format of the canvas to express her response to her subject (her tutor) and probe deeply into his character.

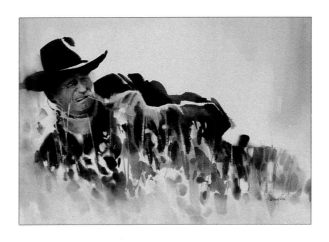

Lining up

Getting the features in correct relation to each other is important in capturing an individual likeness. Use your pencil or brush to check angles and distances between points of importance on the face.

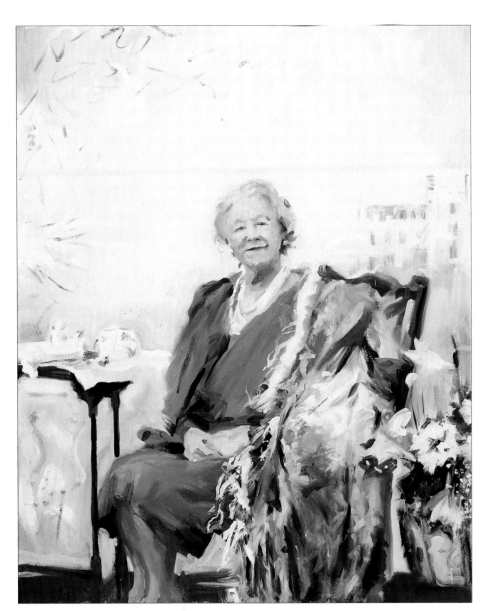

As you work, talk to your sitter and do not be put off if he moves slightly or if his expression alters. If you require the model to sit like a dummy, it will hardly be surprising if the finished portrait looks like one.

Sketch out the framework of the head and shoulders, looking for the dominant angles, masses and shapes. Once these are right you can get down to the finer details. When drawing the facial features, keep checking against the model to see that each is correctly positioned in relation to the other. Does the inner corner of the eye line up with the corner of the mouth? How wide is the mouth in relation to the width of the face? What is the distance between the base of the nose and the upper lip?

Her Majesty the Queen Mother (1988) Howard Morgan, *oil*

The artist responds to the Queen Mother's famous qualities of charm and vivacity, depicting her as "the nation's grandmother". People expose their characters in their faces and in the pose of their bodies; here, the artist has captured the Queen Mother's upright posture, her ready smile and the winsome tilt of her head.

45

ART SCHOOL

LIGHTING A PORTRAIT

Lighting plays an important part in portraits and figure studies. The amount, quality and direction of the light that falls on your subject not only affects the modelling of the features, but it can also influence the mood of the finished painting. It is wise, therefore, to decide what the emphasis of your picture is to be, and illuminate your model accordingly.

There are no hard and fast rules about lighting a sitter, but it is best to avoid using light from more than one source to begin with, as this produces a confusion of tones that makes the job of painting the portrait more difficult than it need be.

Natural daylight is preferable to artificial light because it does not distort the tones of the colours. If possible, set up your "studio" in a room where the light is consistent and unaffected by the sun's movements. In the northern hemisphere, a north light gives the best results; in the southern hemisphere, a south light is preferable.

Three-quarter light

This is the most popular light for portraits and figures, as it lends a strong impression of form and volume, and expresses the character of the subject. The light should be positioned above and slightly to one side of the sitter, so that about three-quarters of the face is lit.

Side light

Here the light falls on the sitter from one side, throwing the other side into shadow. The form and volume of the figure are indicated mainly by the projected shadows. The strong light/dark contrast creates a sense of drama and tension.

Flat lighting

When light falls on the model from directly in front the impression of form and volume is reduced, but the clarity of the colours is enhanced. Some artists dislike flat lighting because it produces a limited range of tones; there are no opportunities to introduce textural variety and the figure may appear flat, looking as if it has been pasted to the background.

Backlighting

When the sitter is positioned in front of a diffuse light source, such as a window, the figure or face is softly shadowed and often there is a luminous halo of light tracing the outer contours. This effect is known as *contre jour*, which means "against the light". Handled skilfully, backlighting can be very effective, particularly where a quiet, subdued effect is desired.

three-quarter light

side light

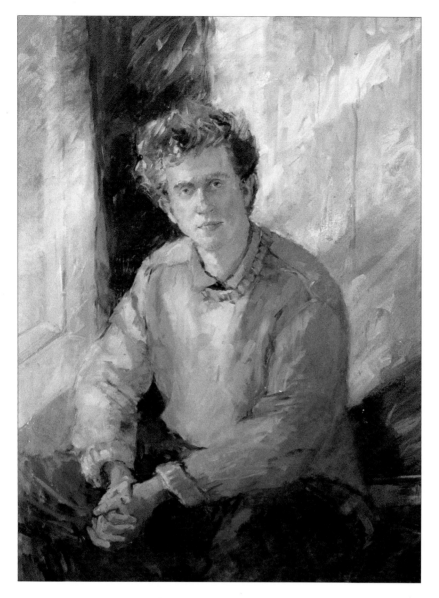

Portrait of a Young Man

Jane Corsellis, *oil*

The lyrical mood of this painting is enhanced by the gentle, diffuse light filtering through the window, softening colours and shapes and setting up an intriguing interplay of warm and cool tones. When painting by natural daylight, remember that as the day develops, so does the angle, colour and intensity of the light. You will need to work quickly, blocking in the light and shadow shapes at the outset, so that they remain consistent as the painting progresses.

▼ Lighting a head

The pencil sketches below illustrate four different ways of lighting a portrait head. Note how the direction of light affects the degree of tonal contrast, which in turn describes the planes and volumes of the face.

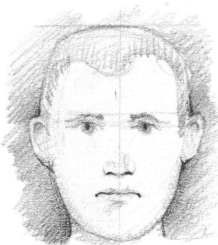

front light

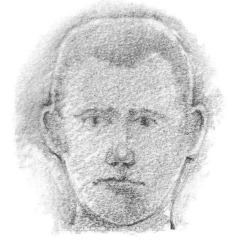

back light

▶ **Saskia** Jane Corsellis, *oil*
For this portrait of a young girl, Corsellis places her sitter against the soft, cool light coming from the window behind, so that her hair is highlighted while the weaker light indoors gently illuminates the features. Lively brushwork and cool, high-key colours contribute to the light, airy, youthful atmosphere of the painting.

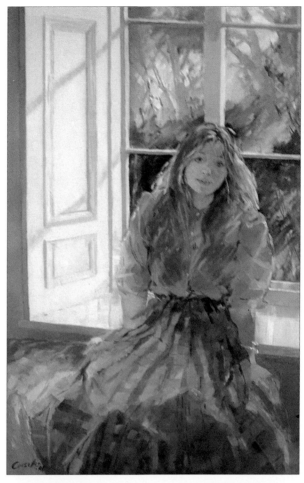

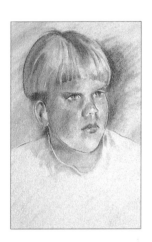

▲ **Phineas** Clifford Hatts, OBE, *red chalk*
In this vignetted study, appropriate technique and well-chosen lighting combine to express not only three-dimensional form but also the individual character of the sitter. Gentle illumination from a frontal angle enhances the clear eyes, fresh complexion and softly rounded forms of the young boy's face. The treatment is soft and misty throughout, except for a few expertly placed linear accents.

▼ **Pub Talk** Douglas Lew, *watercolour*
Even the most ordinary, everyday scene can be transformed by the magic of light – but you may need to work quickly to capture that telling first impression. Douglas Lew worked rapidly in watercolour on damp paper, letting the washes blend wet-in-wet to give an impression of how the strong light coming from a high window behind the figures dissolves the forms in the interior. The luminous highlights are created by leaving areas of the white paper untouched.

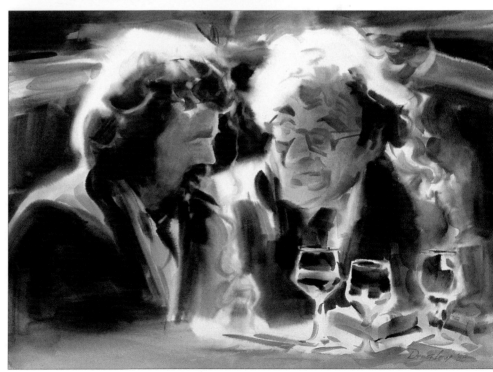

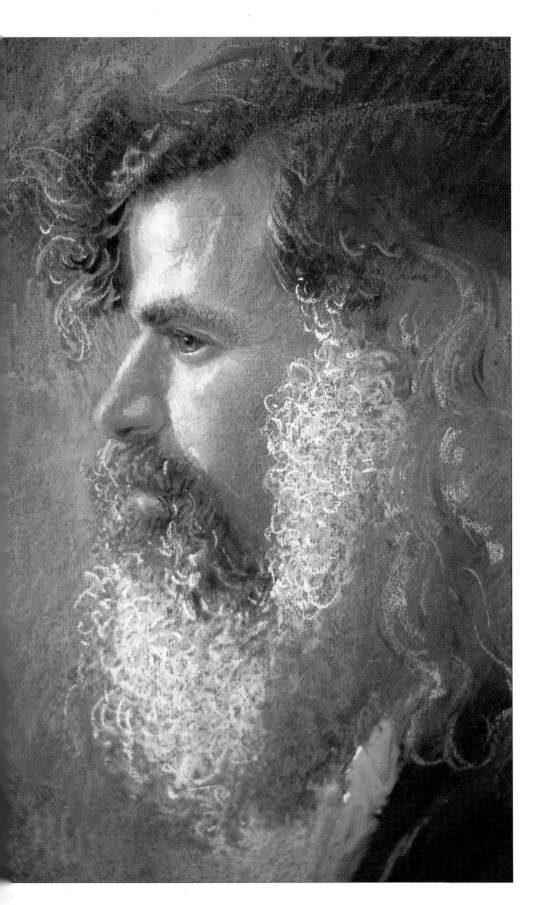

◄ **The Artist** John T Elliot, *pastel*
By lighting the face in an imaginative way, your finished portrait will be visually more interesting, and the play of light on the subject can also suggest emotional undercurrents that go well beyond a mere physical likeness. Here, a strong light coming from the left highlights the model's splendid beard and accentuates the form of the face. Note how expertly the artist has rendered the glow of reflected light in the eye.

▲ **Lewis II** Susan Wilson, *oil*
The subject of this portrait is posed against the light, with strong light also falling from the right, producing extreme contrasts of light and shadow. The paint has been applied with bold strokes of thick paint, following the contours of the face and figure. The background, in contrast, is painted flatly, which focuses attention on the figure and throws it into relief.

·········· Q & A ··········
SELF PORTRAITS

I'd like to paint a self portrait, how do I go about it?

Dürer, Rembrandt and Van Gogh are just three of the great masters who painted self portraits at various stages in their careers, leaving us with a fascinating record of their development, both as people and as artists. Painting a self portrait is a compelling and highly rewarding experience. Studying your own face for hours on end draws you deep into yourself, and the resulting portrait can be surprisingly revealing of your inner feelings and emotions. It is also a liberating experience; it is a great advantage to know that you can work at your own chosen pace and can afford to fail and start again. In yourself, you have a model who is always available and ever-patient. Free from the constraints of producing a flattering likeness of an individual, you can relax, experiment, and allow your style and technique to develop naturally.

Painting a self portrait
To paint a self portrait in oils (bottom) artist Stan Smith set up his easel in front of a mirror with the light source coming from his right.

▶ **1** The artist began with a charcoal underdrawing to work out the composition, the proportions of the head and the modelling of the face. After removing excess charcoal dust with a soft cloth, Smith blocked in the broad areas of light skin tone with burnt sienna and white. Ultramarine was added for the darker tones and cadmium red for the lighter tones.

▼ **2** The darks – the sockets, moustache, beard and hair – were anchored with raw umber (below). Before further developing the face, Smith painted the ultramarine sweater, because its colour affects the flesh tones of the face. Next the mid-tones were blocked in; the lighter side of the face was modelled with mixes of burnt sienna, cadmium red and white, and the lighter areas in the shadows with a mix of raw umber and white.

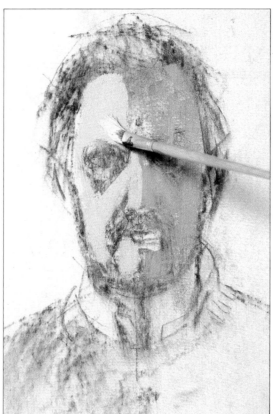

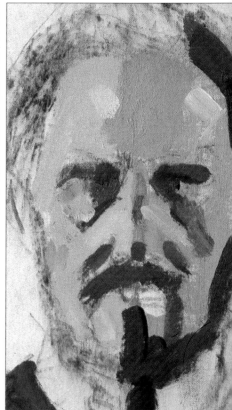

▼ 3 The background consists of vigorous strokes of raw sienna and white. The skin tones were refined by adding warm yellowish tints in the light areas and cool bluish tints in the shadows.

▶ 4 Smith darkened the ground with raw sienna and painted the pink areas of the ears, mouth, cheek and neck with a mixture of cadmium red, white and a touch of raw sienna.

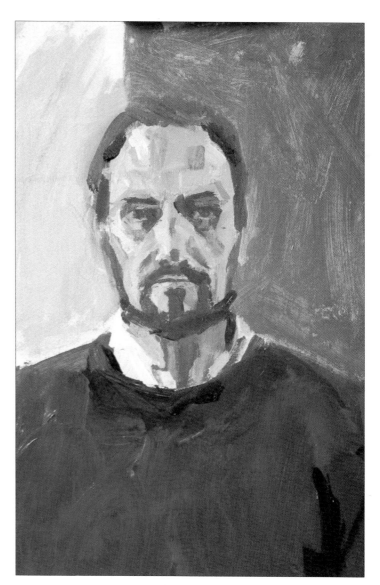

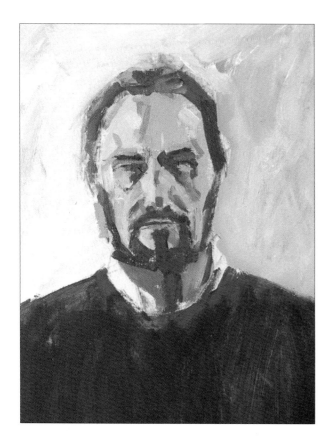

At first, try not to become obsessed with producing an accurate likeness. Treat the features of your face as you would a landscape or a still life: seek out interesting aspects of form and shape, the play of light and shade, and the infinite subtleties of surface texture. Before starting to paint, make detailed sketches of individual features and try out different lighting set-ups and backgrounds as well as different poses and expressions. This process of getting to know yourself is not only absorbing and enjoyable, it is also of invaluable help later, when you begin to paint.

It is important to set up a self portrait correctly. Stand your mirror at an angle that allows you to see yourself easily without twisting or stretching. Do not forget that your image will be reversed in the mirror. This may not worry you but, if you find it disconcerting, simply arrange two mirrors – one in front of you and one behind – so that you can paint the reflection of the reflection.

You should be able to look from your working surface to the mirror by shifting your gaze, not your body. Place the mirror and your painting equipment close together as near to the light source as possible, because the reflection in the mirror will be slightly duller than it would if you were working from life. In addition, you will need to position your mirror, painting surface and colours so that they are illuminated equally by the light source, which will enable you to judge your colours correctly.

It is a good idea to mark both the position of the easel and that of your feet, so that when you step back or leave the painting for any period of time you will be able to resume the exact position and pose.

LEARNING FROM THE
MASTERS
REMBRANDT

R embrandt is widely acknowledged as being one of the greatest painters of all time. His skill as a portraitist brought him early success, but he soon drew away from the conventional portraiture of his day in search of a more profound expression of the inner character and spirituality of his subjects. His portraits have a penetrating intimacy and

seem to vibrate with an inner warmth and humanity. Throughout his life, Rembrandt painted many self portraits, in which he recorded his psychological and physical changes with a complete mastery of the medium, combined with acute self-awareness. *Self-portrait with Maulstick, Palette and Brushes* was painted a few years before he died, and depicts the gravity and dignity of old age.

▲ This detail is taken from the hair. The texture, form and play of light on the artist's greying curls is marvellously realized; small directional strokes of a dull ochre are applied rapidly, followed by delicate touches of white impasto, dragged on with a dry brush. The impressions left by the hairs of the brush contribute to the texture and movement of the curls.

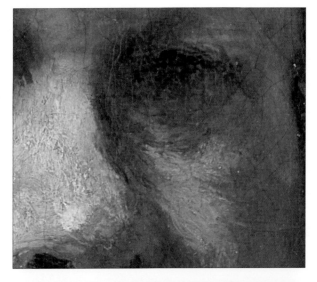

Rembrandt's technical mastery of the oil medium and his sheer breadth of handling are displayed in this detail. The paint is freely worked wet-in-wet, rubbed, scrubbed and dabbed to create a rich, broken surface texture that reflects actual light and conveys both an impression of three-dimensional form and the actual texture of the old man's skin. As in many of his mature portraits, the exact expression of the eyes is concealed in deep shadow, thus strengthening the impression of a sombre inner mood.

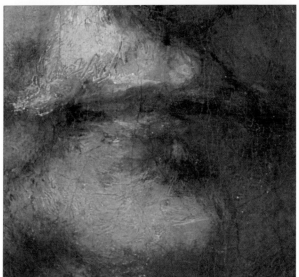

The mouth, like the eyes, emerges from shadow and is barely suggested, so that we are forced to complete the expression in our own mind's eye. The greyish-green underpainting is discernible in the shadows around the mouth and under the chin. The thin grey moustache is created by scratching with a sharp instrument directly into the wet paint.

Self-portrait with Maulstick,
Palette and Brushes, c. 1663
oil on canvas
72cm × 76cm (28in × 30in)
Iveagh Bequest, Kenwood House,
London

Technique and human feeling are marvellously combined in this moving image of the artist in his late middle-age. The figure emerges out of dusk, giving an impressive isolation to the personality of the artist. In his searching, self-scrutinizing expression, we see what Van Gogh described as "that tenderness in the gaze ... that heartbroken tenderness, that glimpse of a superhuman infinite". In contrast to some of Rembrandt's earlier self portraits, here there is no reliance on theatrical "props" or costumes. All extraneous details are sacrificed to the expression of a profound psychological and emotional insight into the human spirit, at once majestic and fallible. The restrained harmony of the cool, muted colour scheme, combined with the stark simplicity of the composition, underline the sense of brooding monumentality achieved.

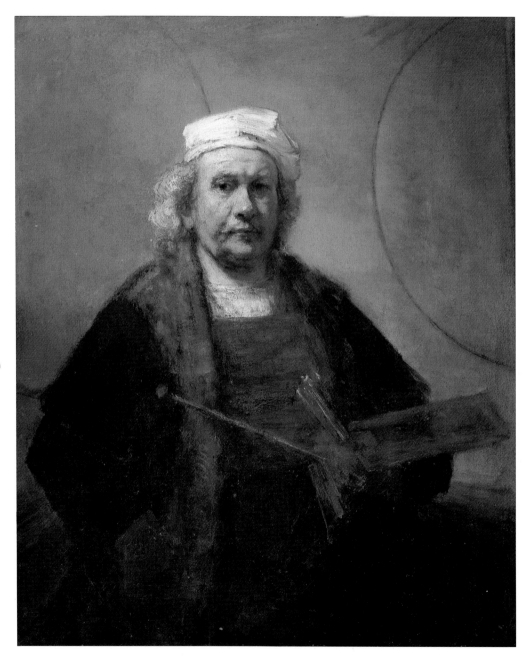

IAN SIDAWAY
PORTRAIT OF A CHILD

Portrait of a child

In this demonstration artist Ian Sidaway tackles an apparently difficult subject – a portrait of a young child. He follows the classical watercolour technique, building up the fleshtones with a series of pale washes that keep the colours fresh and lively. A combination of wet-on-wet and wet-on-dry creates soft tones and crisp shadows.

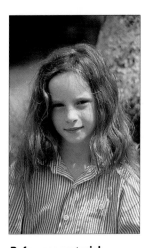

Reference material

For this portrait of a young girl, the artist worked from an informal snapshot taken outdoors. The portrait is painted in watercolour, which is ideal for capturing the freshness of a child's skin.

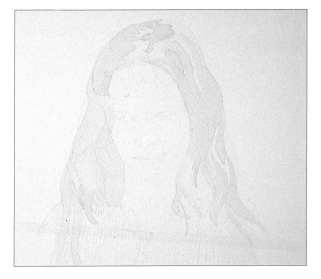

◄ **1** The artist begins by lightly drawing the outlines of the subject and defining the main tonal areas of the skin and hair. These lines act as a precise guide for the tones and colours that are to follow. A highly diluted wash of brown madder alizarin and chrome yellow is applied to the face and neck, establishing the lightest skin tones. The hair is painted with a similarly pale wash of chrome yellow and yellow ochre. The paint is allowed to dry.

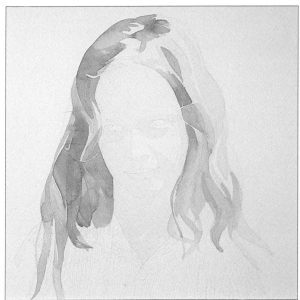

◄ **2** A slightly more intense mixture of brown madder alizarin and chrome yellow is applied to the face and neck, leaving the highlighted areas untouched. The mid-tones in the hair are painted with a mix of chrome yellow and yellow ochre, darkened with more yellow ochre and sepia. The strands of hair are treated as flat shapes, leaving the pale yellow highlight areas untouched. Notice how the pencil drawing helps the artist to identify the different tonal areas.

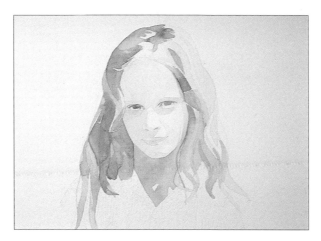

3 The tones on the face are developed with a warm shadow colour mixed from the skin tone used in step 1, darkened with brown madder alizarin and yellow ochre. A mix of Payne's grey and sepia is used for the darks of the eyes, which are painted very simply.

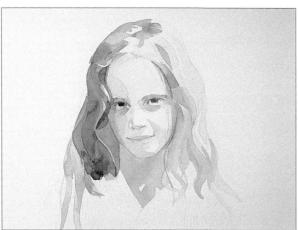

4 The dark areas in the hair are further defined with a mix of yellow ochre, sepia and Payne's grey. The shadow areas of the face, particularly in the eye sockets and the area beneath the chin, are darkened with brown madder alizarin and cobalt blue.

5 This close-up detail of the face shows how the forms are beginning to build up gradually with a logical sequence of light, middle and dark tones. The mouth and nostrils are painted with brown madder alizarin and yellow ochre. With a subject like this, made up of pale colours, it is often difficult to identify the modulations of tone. One way of overcoming this problem is to study the subject through half-closed eyes. By using transparent washes that allow the white of the paper to shine up through the colours, and by keeping the tones simple, and clearly defined, the artist achieves the freshness and translucency of young skin.

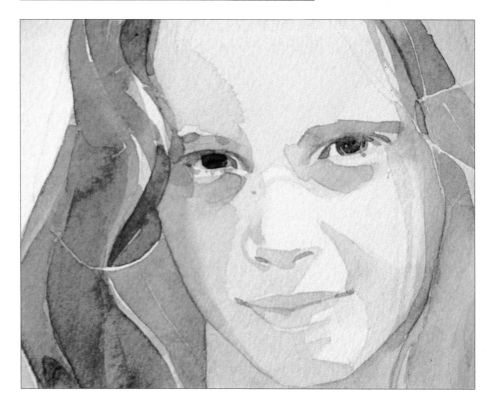

55

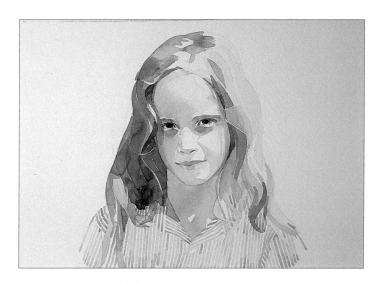

◄ 6 Sidaway now adds a little gum water (a diluted form of gum arabic) to his colour mixes. The gum water intensifies the colours slightly and makes the paint more soluble; this causes subsequent colours to blend into the initial layers, thus avoiding hard, unnatural edges. The striped pattern of the shirt is painted with a diluted mixture of cobalt blue and Payne's grey. The lighter stripes are painted first, with further washes added for the darker areas.

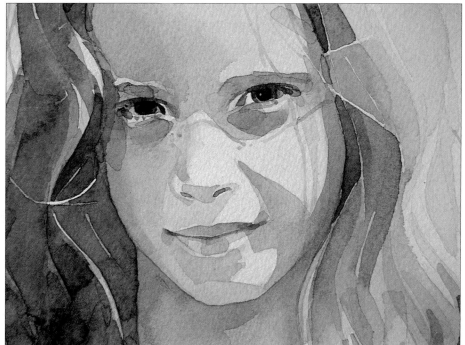

◄ 7 In this detail from step 6, we can see how the rounded and angular forms of the face are expressed with a combination of soft wet-in-wet washes and crisp wet-on-dry areas. The hair on the side of the face is further darkened with yellow ochre and Payne's grey, and the shadows on the face with brown madder alizarin and cobalt blue.

► 8 The artist continues to develop detail in the face, darkening and defining the eyes, eyebrows, lips and parts of the hair. The shadow on the shirt is painted with a wash of Payne's grey and yellow ochre.

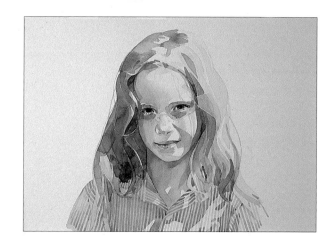

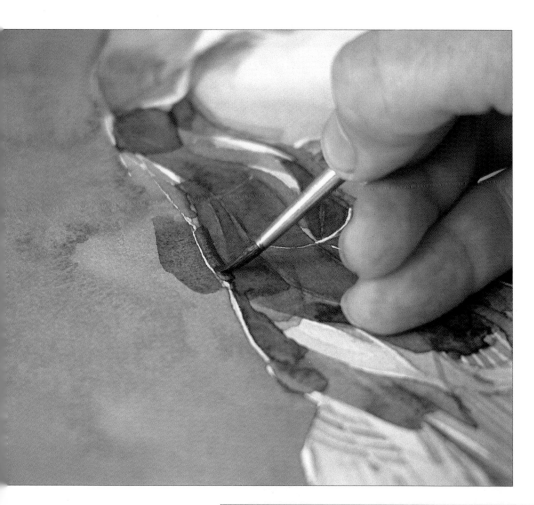

9 The painting is almost finished, and Sidaway now paints the background with a wash of viridian, sepia and Payne's grey, which he scumbles on freely, working quickly with a loaded brush. He is not concerned with achieving an even wash, because a textured finish breaks up the surface and adds interest to the painting. This detail shows how he cuts into the hair on the left side with the background colour, thus leaving thin light strands showing through.

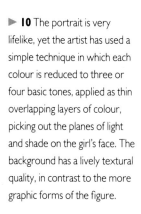

10 The portrait is very lifelike, yet the artist has used a simple technique in which each colour is reduced to three or four basic tones, applied as thin overlapping layers of colour, picking out the planes of light and shade on the girl's face. The background has a lively textural quality, in contrast to the more graphic forms of the figure.

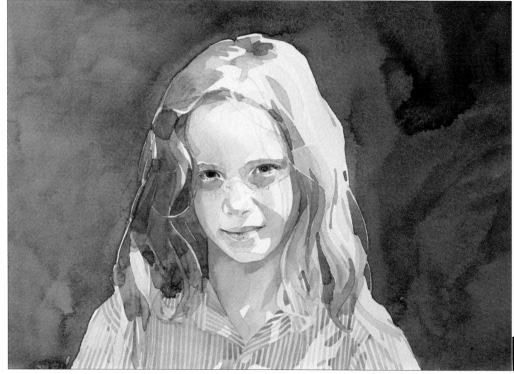

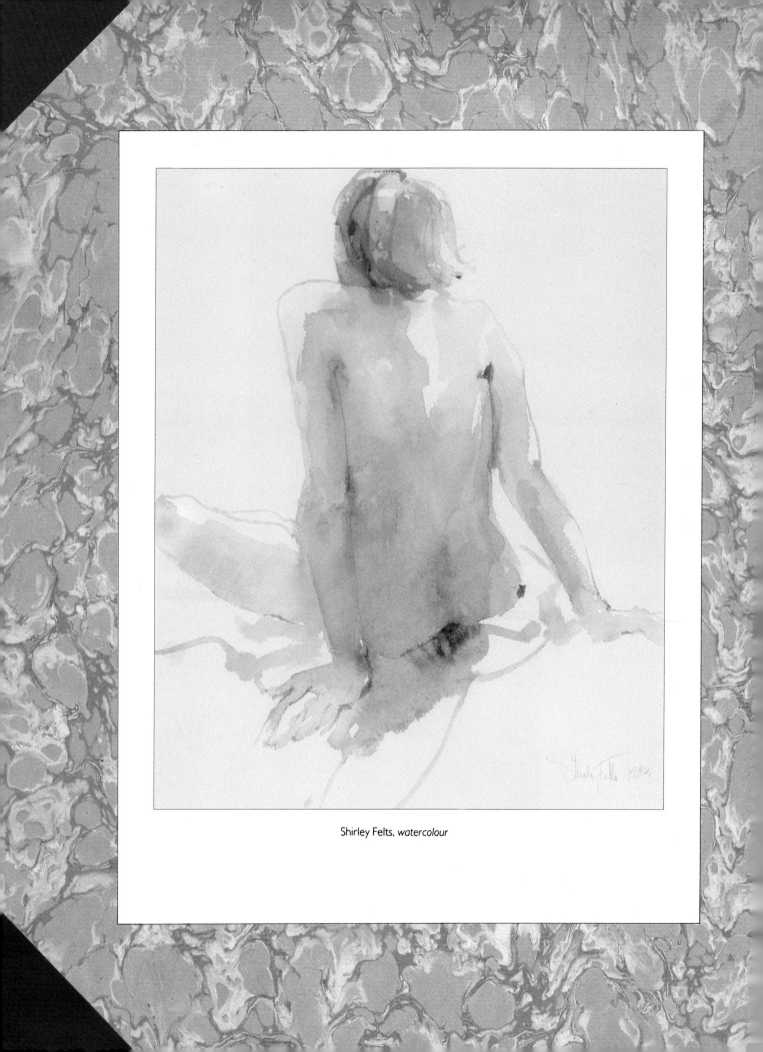

Shirley Felts, *watercolour*

PART 2

···

FIGURE
STUDIES

···

"IT IS NOT BRIGHT COLOURS BUT GOOD DRAWING
THAT MAKES FIGURES BEAUTIFUL"
TITIAN

ART SCHOOL

· ·

PROPORTIONS OF THE FIGURE

The key to successful figure drawing is to get the various parts of the body in their correct proportions. This is easier said than done, since our eyes tend to mislead us into seeing some parts as larger or smaller than they really are. The hands and feet, for example, are frequently drawn too small.

Most artists gauge body proportions by taking the head as their unit of measurement. Allowing for slight differences from one person to another, the adult human figure measures seven to seven-and-a-half heads from top to bottom. Although no two people are exactly alike, it is helpful to memorize the proportions of the "ideal" figure and keep these in mind as you draw.

▼ **Birth to maturity**
These illustrations show the pattern of physical growth from birth to maturity. The average adult body is about seven or eight heads tall; a child's body is about five heads tall; in babies, the body is about three heads tall, and the legs are proportionately shorter.

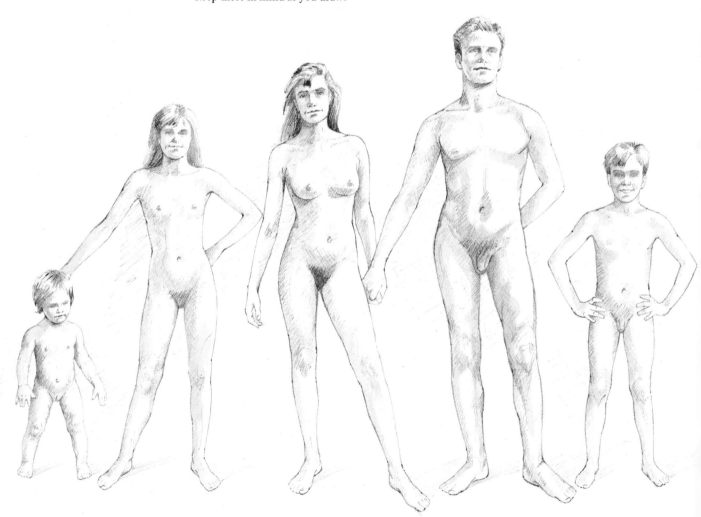

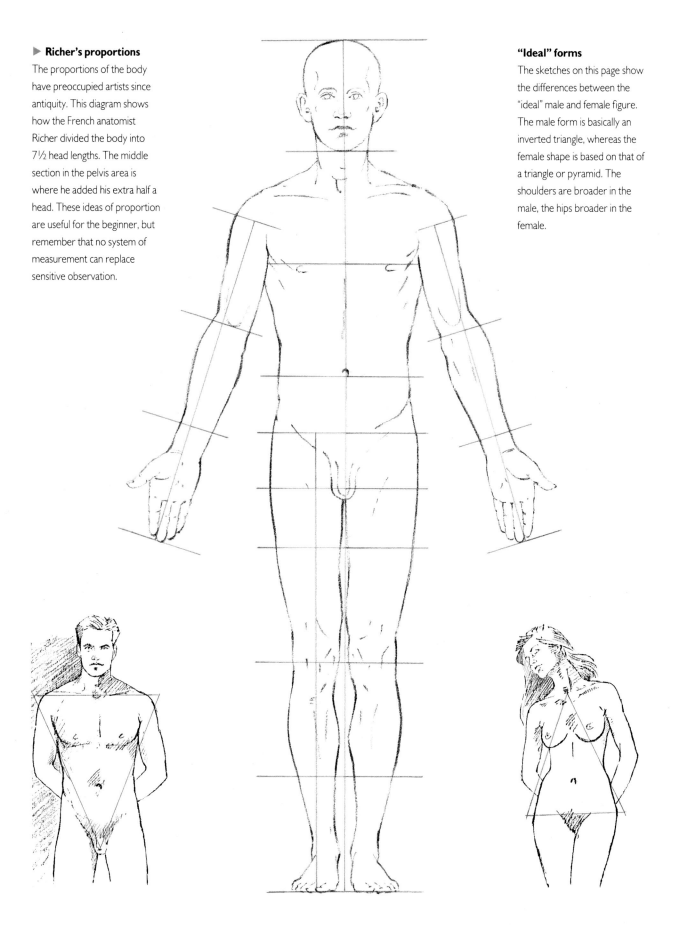

▶ **Richer's proportions**

The proportions of the body have preoccupied artists since antiquity. This diagram shows how the French anatomist Richer divided the body into 7½ head lengths. The middle section in the pelvis area is where he added his extra half a head. These ideas of proportion are useful for the beginner, but remember that no system of measurement can replace sensitive observation.

"Ideal" forms

The sketches on this page show the differences between the "ideal" male and female figure. The male form is basically an inverted triangle, whereas the female shape is based on that of a triangle or pyramid. The shoulders are broader in the male, the hips broader in the female.

61

3 Girls Balancing Brenda
Godsell, *charcoal and pastel*
Once you have learned the rules
of proportion, there is no
reason why you cannot break
them occasionally in the interests
of expressing your vision. When
the inspiration that you feel
flows out through your hand
unhindered, slight exaggerations
and distortions may inject life
into your work. In this spirited
drawing, the deliberate
elongation of the dancers' limbs
helps to express the dynamic
energy of the subject.

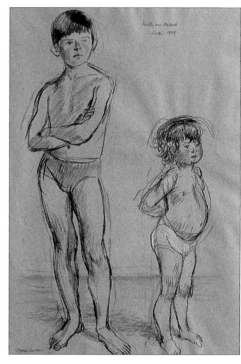

Timothy and Melanie
Stephen Crowther, *charcoal and
conté*
As children grow they not only
become taller, but the general
proportions of the body change,
with the head becoming smaller
in relation to the body. Note the
chubby volume of the cheeks
and body in the younger child, as
compared to the leaner
appearance of the older child.

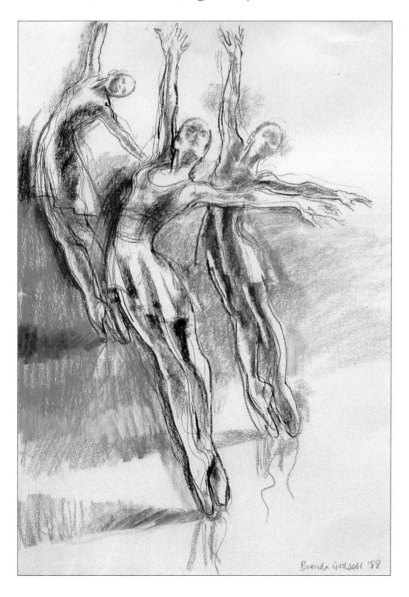

▶ **Nude** Rudolph Katchaturian,
sepia
When the figure is seated, the
measurement from the top of
the head to the feet may be
around six head lengths,
depending on the pose. The
chair is also a useful guide in
establishing the proportions of
the figure.

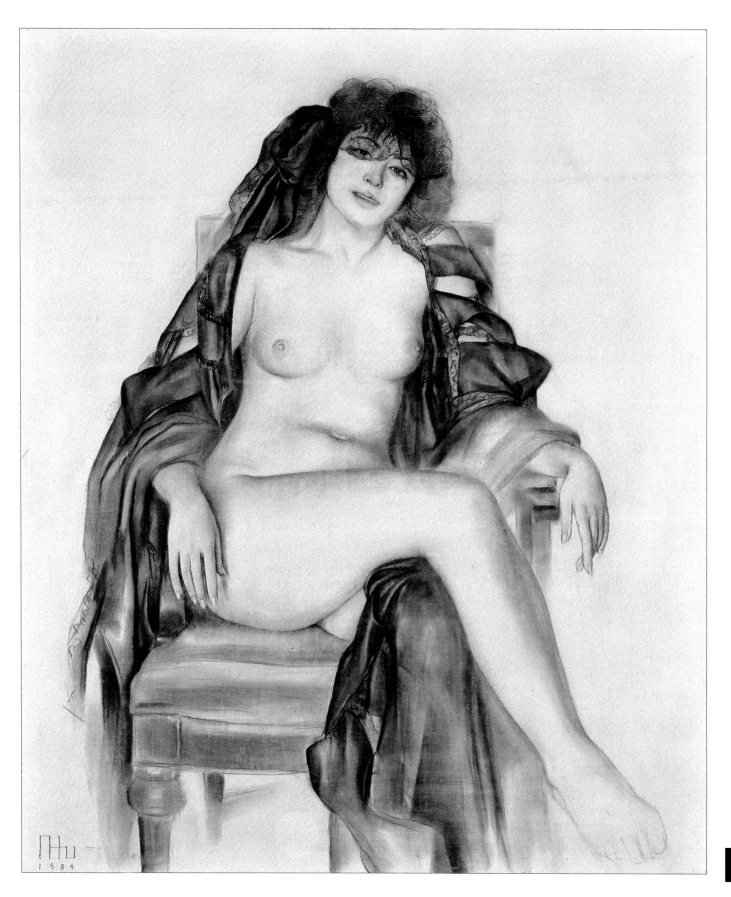

ART SCHOOL

· ·

MEASURING WITH THE PENCIL-AND-THUMB METHOD

The average adult human figure is about seven heads high, so if your model happens to be standing perfectly upright it should not be too difficult to gauge the proportions correctly. But what if your model is sprawled in a chair or bending from the waist? What if the arms and legs are foreshortened at the angle from which the subject is being viewed? In this case, it is more difficult to relate the size of one part of the figure to the other parts in such a way that they all end up in correct proportion.

One way to keep a note of proportions while you draw is to treat your pencil as a measuring tool, using it to check and compare the relative angles and dimensions of the various parts of the figure in relation to each other. To use the pencil-and-thumb method, grasp your pencil near the base, between your thumb and first finger, so that it extends either horizontally or vertically, depending on your requirements. Hold the pencil at arm's length, with your elbow locked, so that the pencil lines up in front of your subject. Keeping your arm and head still, close one eye and look along the pencil at your subject. This will be the basic position for all the measuring techniques described below.

Comparative measurements

With this technique, you use your pencil to measure the width or length of one part of the figure and compare it to the width or length of another part, as an aid to accurate proportions. With your arm extended, line up the pencil tip with, say, the top of the model's head, and mark the position of the chin with your thumbnail. Or you might wish to use the length of an arm from shoulder to elbow as your unit of measurement. Now you can compare the length of your key measurement with other parts of the body. Keeping your thumbnail in position and your arm still extended, move the pencil to another part of the figure, such as the upper leg or the width across the shoulders, and compare its length with the length of your key measurement.

It does not matter if your drawing is proportionately larger or smaller than the subject at the end of your pencil. What this method achieves is to ensure that the relationship between limbs, head and torso is correct.

▶ **Gauging proportions**
Most artists gauge body proportions by taking the head as their unit of measurement. The average adult figure is between seven and eight heads tall.

◀ **Sight lines**
When using the pencil-and-thumb method for gauging proportions, always hold your pencil at arm's length, with your elbow locked: if you bend your arm, your measurements will be inaccurate. Line up your pencil against the subject, close one eye, and move your thumbnail up or down to take the required measurement.

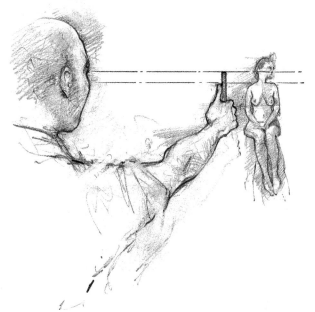

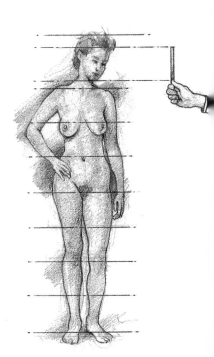

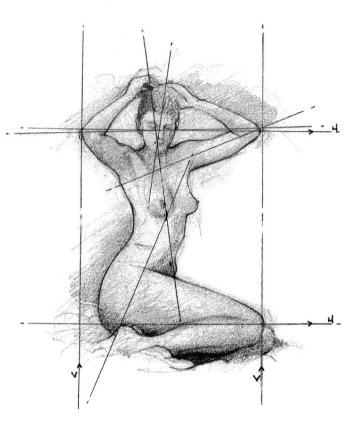

◄ ► Boxed in

Sometimes the outline of a
posed figure will "fit" within the
confines of a square or
rectangle. Make a rough outline
of the figure and then lightly
draw lines over it, as shown. This
helps you to see the outline of
the figure more clearly, as you
can relate it to the horizontals
and verticals of the drawn lines.
This method is not only useful in
checking proportions, it will also
help you to capture the action of
the pose.

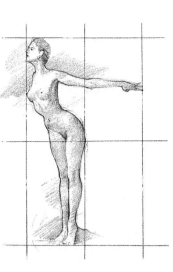

◄ Alignments

When drawing figures, try using
your pencil like a carpenter's
spirit level or plumbline, to
check the horizontal, vertical and
diagonal alignments of your
subject. Extend your pencil over
your subject and turn it this way
and that to see which parts of
the figure line up with other
parts. Drawing an imaginary
vertical down the centre of the
body will help you to work out
the variations in symmetry
between either side.

▼ Finding the centre line

Study your subject and estimate
the halfway point, either
horizontally or vertically. By
dividing the figure into two
manageable halves, you will
find it easier to get the
proportions accurate.

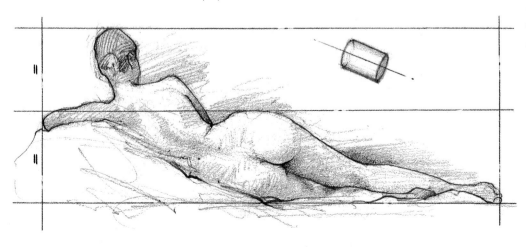

ART SCHOOL

FORESHORTENING

The reason why foreshortening is so difficult to grasp is that people tend to draw what their mind tells them is correct (that a head is always larger than a hand), not what they see (that when a hand is closer to the viewer than a head, the hand may appear larger). Foreshortened shapes often appear nonsensical, and the temptation is to alter them to make them more recognizable. Unfortunately, that is when things start to go wrong. Force yourself to trust what your eyes tell you; keep drawing, and everything will fall magically into place at the end. Once you have become accustomed to drawing what you see, regardless of how extraordinary it appears, foreshortening should come to you more easily and will add an exciting new dimension to your work.

When drawing foreshortened figures, it is particularly important to use your eyes; you must repeatedly look at your model, then at your drawing, and back again, to check that angles and proportions are correct (you will find the pencil-and-thumb measuring method described on page 64 invaluable). Use your pencil to find points on the body which align, horizontally or vertically, and observe the negative shapes that occur between the solid forms of the body.

If you still have problems with foreshortening, try marking out a large box on your paper and fitting the figure into it. Draw in the part of the body nearest to you and the part farthest away, then gradually connect the two points. In this way, you are more likely to get the proportions correct. Above all, keep your drawing loose and flexible so that you can make corrections and adjustments as you go along.

▼ Sketch: My Neighbour's Son Juliette Palmer, *pen and ink*
Here the artist has conveyed the foreshortening of the boy's right arm and leg skilfully, even without the use of light and shade to indicate form. Once you learn to trust what your eyes tell you, you will be able to draw as confidently as this!

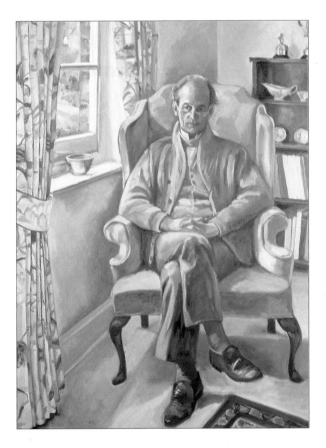

Portrait of John Raison Suzie Balazs, *oil*
A seated figure presents the problem of conveying the foreshortening of the thighs, which is notoriously difficult to represent convincingly. Pay careful attention to the way in which light and shade fall on the legs, as this helps to indicate their form and their position relative to each other.

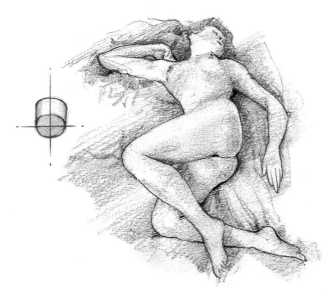

◄ **Positive and negative shapes**

This pose may appear complex, but if you look at the figure as a two-dimensional shape, like a flat puzzle-piece, you will find it easier to draw the foreshortened outline convincingly. As an aid to accuracy, observe not only the "positive" shapes formed by the various parts of the figure but also the "negative" shapes around and between them.

Checking proportions

Try using the head as a unit of measurement for checking the proportions of a foreshortened figure.

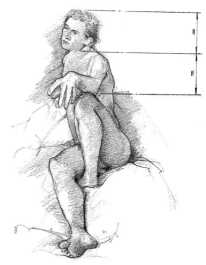

▼ **Figure perspective**

As with all forms in nature, those of the human figure are subject to the laws of perspective. Lay a glass tumbler on its side and turn it at various angles; the more you can see of the end of the tumbler, the less you can see of its sides. The same principle applies to a reclining figure.

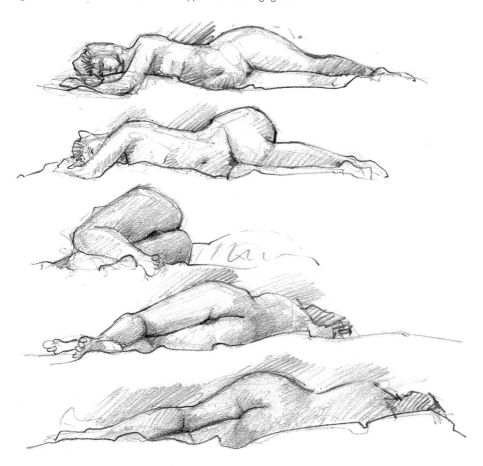

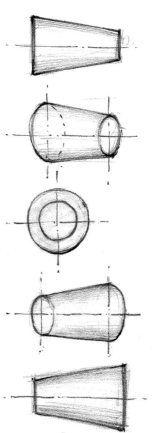

67

HANDS

How can I improve
my drawing of hands?

Beginners often shy away from including hands in their portraits and figure studies, cunningly hiding them in pockets or arranging them carefully out of sight. Hands certainly present a challenge, but this challenge is worth persevering with, because hands are particularly expressive of character and individuality.

Portraying hands convincingly is largely a matter of getting the proportions right. As a guide, the fingers are about half the length of the whole hand, and the width across the knuckles is about the same as the length of the fingers.

Drawing your hands
Get plenty of practice drawing your own hands, taking note of the following points.

The width across the knuckles is about the same as the length of the fingers.

The finger-bones extend beyond the knuckles into the back of the hand.

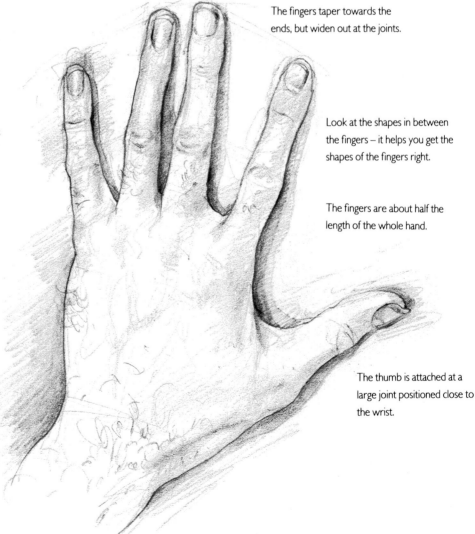

The fingers taper towards the ends, but widen out at the joints.

Look at the shapes in between the fingers – it helps you get the shapes of the fingers right.

The fingers are about half the length of the whole hand.

The thumb is attached at a large joint positioned close to the wrist.

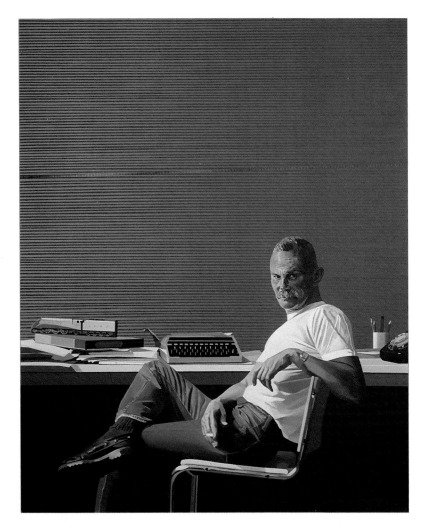

Michael J Franklyn

Ian Sidaway, *oil*

Hands can bring a portrait alive and give animation to the pose. Where possible, try to avoid placing both hands on the same level as this may create a rather static composition. Instead, arrange the hands in a natural and relaxed way, as Ian Sidaway has done here.

The hands are bigger than you might think. Stand in front of a mirror and hold your hand up to your face, with the base of the palm resting on your chin. You will see that from the wrist to the fingertips your hand is almost as long as your face and about half as wide.

Hands are easier to draw if you start by reducing the palm area, thumb and fingers to basic geometric shapes. Once you are happy with the proportions and the outline shape of the hand, you can begin to refine the forms, erasing the guidelines as you go. Light and shade are important in describing the form and positioning of the hand. Unless you are making a detailed study, reduce the tones to just three – light, dark and one mid-tone. Any more than this and you will notice that the hands begin to lose their sense of form.

If you look at portraits by professional artists, you will see that the hands are portrayed quite sketchily and yet they look convincing. Indeed, if the hands are rendered in too much detail they compete with the face for attention.

▲ ▼ **Observing the joints**

Close observation is the only way to understand all the complex articulations of the hand. Note particularly the way in which the hand bends at the wrist, and how the fingers each have their own movements.

69

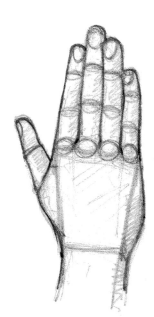

◄ ► Block sketches

To simplify the process of drawing hands, it can be helpful to begin by making block sketches like these, in which the various joints and planes are treated as geometric shapes. Observe the positions of the fingers in relation to one another, and describe the pattern of light and shade which gives them three-dimensional form.

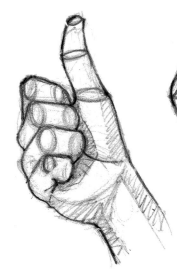

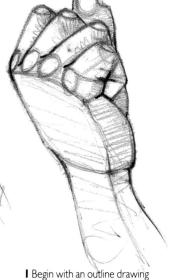

Form and volume of the hand

The step-by-step sequence in watercolour, *below*, by David Curtis, shows how to paint a hand by building up tone and colour gradually, working from light to dark.

1 Begin with an outline drawing in pencil.

2 Build up the shading with hatched pencil strokes, then apply an allover wash of raw sienna and light red, diluted to a pale tone. Allow to dry.

3 Apply successive washes wet-over-dry to define the mid-tones.

4 Use a mix of cerulean blue and light red for the darkest tones, then redefine the pencil shading to give weight to the image.

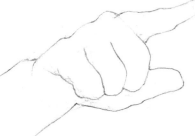

1

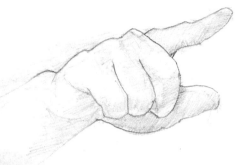

2

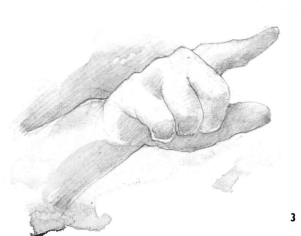

3

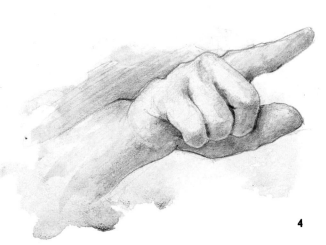

4

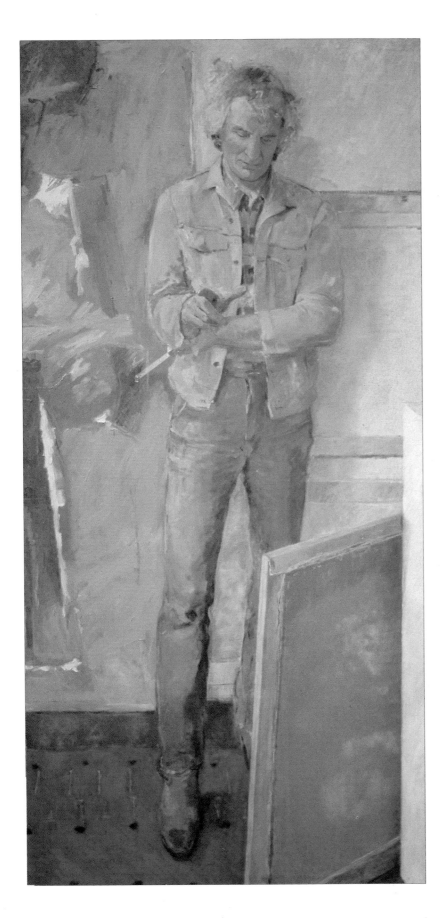

Moving Pictures

Linda Atherton, *oil*

When painting a full-figure portrait, it is important to give your model something to do with his or her hands, otherwise the pose may look stiff and wooden. Here, Linda Atherton has made a brave choice in depicting a foreshortened hand – not the easiest of subjects! The detail, *above*, shows how the artist has observed carefully the lie of each finger in relation to the next. The form of the hand is expressed quite simply with three basic skin tones – light, medium and dark – yet it "reads" accurately.

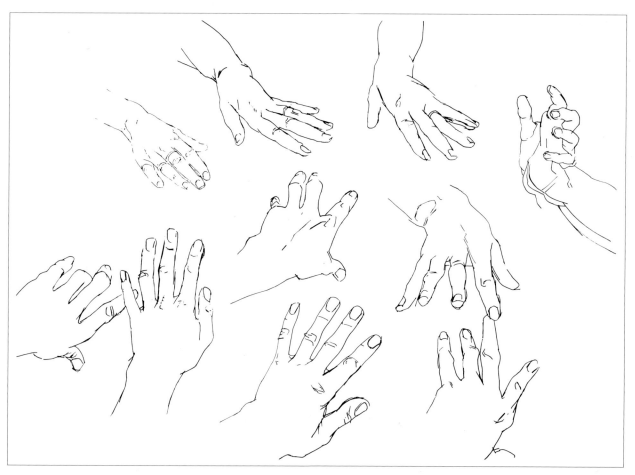

▲ Contour drawings

When you draw hands, you will often encounter a conflict between what you see and what you know, because in certain positions the hands make rather odd shapes. To counteract this, try making contour drawings like these, drawing the outlines only and putting down the shapes exactly as you see them.

Rupert Playing Guitar

Gabriella Baldwin-Pinny
The hands are an important element in any portrait of a musician. In this painting the head and hands form a triangular composition, which encourages the eye to move around the image.

72

Mrs Snow Stephen Crowther,
oil

A good portrait makes us feel that we are face to face with a living, breathing person, and conveys the rapport between artist and sitter. This is just such a portrait. The old lady's hands, carefully folded in her lap, express as much about her as does her face. The detail of the hands, *below*, shows how Crowther represents them simply and directly, but with careful attention to form. Try to think of the hands as complete structures, with planes of light and shadow, and resist the temptation to paint each finger separately – the result invariably resembles a bunch of bananas!

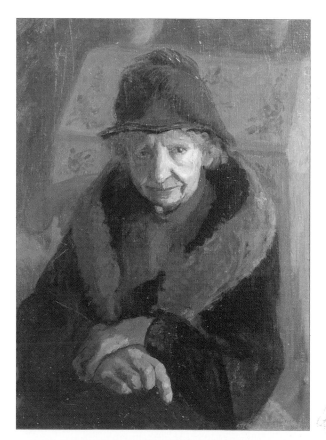

▼ Action studies

Hands are capable of an almost endless range of movements and you can only hope to draw them well if you sketch them in as many positions as possible. The more positions you sketch, the sooner you will understand the anatomy of the hand.

73

Q & A
RESTATING

My figure drawings look stiff and wooden. How can I make them more alive?

Seated Girl *Jane Corsellis*
In this portrait study, Corsellis has combined lively brush work and fluid washes with the more overtly linear marks of pen and ink. Line-and-wash drawings are highly expressive, suggesting more than is actually revealed. The secret is to work rapidly and intuitively, allowing the washes to flow over the "boundaries" of the drawn lines and not be constricted by them.

One of the greatest barriers to good drawing is fear of failure. Lacking confidence, the beginner carefully draws a few hesitant lines and then, dissatisfied, furiously rubs them out and starts again. He moves on to the next area of the drawing – the nose looks wrong, or the hand is a few millimetres out of place. Bother! More frantic rubbing out. Eventually the drawing is finished, and inevitably it is a disappointing hotchpotch of disconnected parts. The figure looks stiff and lifeless – a tailor's dummy instead of a living, breathing person.

One way to overcome this problem is to make a series of sketches without using an eraser. When mistakes and distortions occur, simply leave them in and draw the more accurate lines alongside. In other words, restate the lines. Your finished drawings may not be neat and perfect, but they will certainly look more alive and energetic. The restated lines give a sense of movement to the figure.

Drawing is a vital, changing process, a voyage of discovery. Feeling out the forms, adjusting and correcting, are all elements of this process, and indeed they form a large part of the sheer pleasure of drawing.

Watching TV Michael MacLeod, *felt pen*
MacLeod made this rapid sketch of his children while they were engrossed in watching the last night of the promenade concerts on TV. You have to hold your breath a bit when using felt pen, because lines cannot be erased once they are on the paper – but that in itself can be a spur to good drawing, because it gets the adrenalin going and forces you to work boldly. Notice the subtle effect of a felt pen that is running out of ink and producing a drier line.

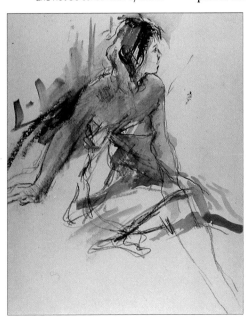

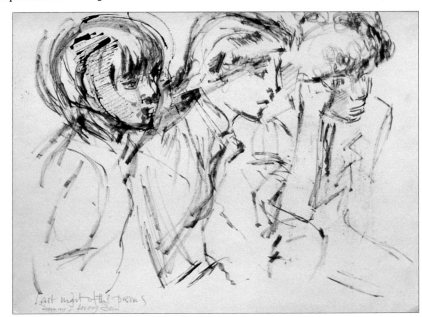

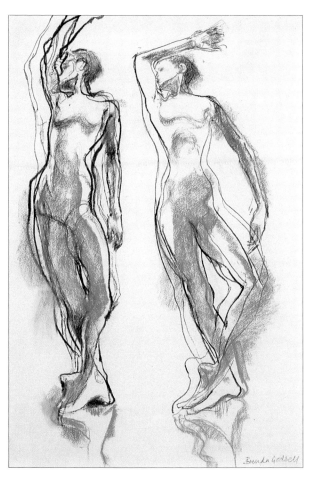

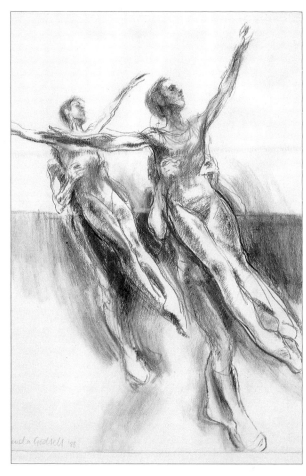

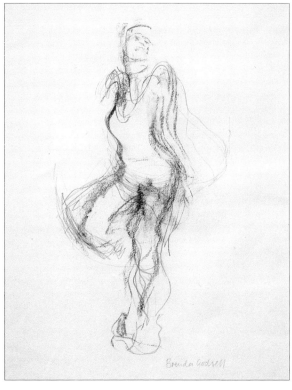

▲ **Bodies;** ▲ **Girls Leaping;**
and ▶ **Whirling Dance**
Brenda Godsell, *all are charcoal
and pastel*
In these sketches of dancers,
Godsell portrays the vitality,
grace and beauty of the human
body in motion. Charcoal, pastel
and pencil are sympathetic
mediums for drawing,
responding immediately to the
artist's impulse.

▲ **Sketchbook page** Stan
Smith, *fibre-tip pen*
The restated lines, as in the bent
arm of the standing figure, do
not detract from this drawing at
all; in fact they add an extra
dimension, allowing us to see the
drawing process at work.

ART SCHOOL

· ·

BALANCE AND ARTICULATION

The human body is symmetrical, so when a movement is made on one side, the other side has to compensate in some way. It is all a matter of balance and weight distribution. For example, when the weight is on both legs, the hips are level. When the weight is on one leg, the hip on the side of the supporting leg is pushed upward. Notice also that the angle of the shoulders runs contrary to the angle of the hips, so that the body balances.

Similarly, when the body is performing certain actions, such as pushing, pulling, leaning and stretching, it automatically balances itself to compensate for the weight or force of the action.

A good way to work out the balance and weight distribution of your model is to look out for the horizontal axes, or directional lines, formed by the eyes, shoulders, elbows, nipples, hips, buttocks, knees and ankles. All of these features occur in pairs, so by establishing their angles

you can understand and reproduce the model's stance. If you have difficulty with some of the angles, glance at them on the model, and then on your drawing, over and over again, switching from one to the other very quickly. After doing this for a short while, you will find that the image of the model sets on your drawing. It is also a useful exercise to imitate the position of the model yourself before you begin drawing, in order to get a sense of the way in which the body weight is distributed.

Thinking in a vertical direction now, observe the angle and positioning of the model's head, neck, hips, knees and feet in relation to each other. As a reference, you can use any vertical in the background, such as the corner of the room or a door-frame. Having studied the model's pose and understood it, start your drawing by lightly marking out the major axis lines of the shoulders, hips, knees and ankles, as shown in the illustrations below.

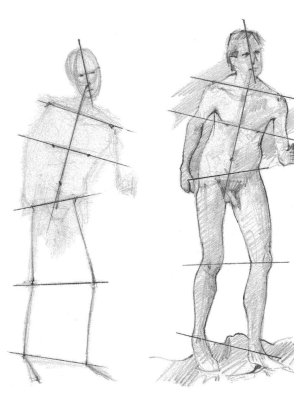

Sketch the pose

When drawing figures in action, try making faint lines like these to determine the main directional lines of the pose. Draw lines along the axes of the shoulders, chest, hips, knees and ankles, and plot the vertical angles of the head and torso.

Complete the drawing

Draw in the outline of the figure, paying close attention to the axes you have drawn. Alter the pressure on your pencil to emphasize the form, remembering that a dark line comes forward and a faint line recedes. Finally, build up the shadow tones.

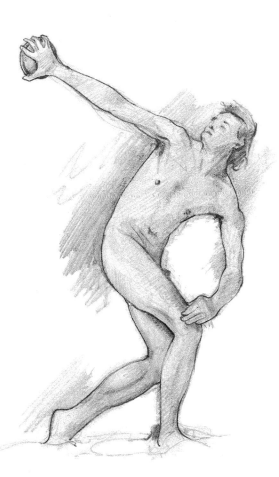

▶ ▶ Movement and posture

In order to stay upright, a standing figure must arrange itself around a centre of gravity. These drawings show how the figure makes compensatory movements to accommodate this. Notice how, as one side of the figure stretches, the other contracts. When drawing the clothed figure, it is important to give a sense of the structure and weight distribution of the body beneath the clothes.

▼ Contrapposto

Although the human form is symmetrical, it should be represented in a way that also illustrates its dynamic qualities. One way to achieve this is through the classical technique called *contrapposto*, meaning "opposite positions". In this drawing, for example, the slope of the shoulders runs contrary to the slope of the hips.

◀ ▲ Balancing act

These figure drawings show how the body balances itself when performing actions of various kinds. When drawing from life, it can be useful to imitate the position of the model yourself before you draw it, to get a feeling for the body's weight distribution.

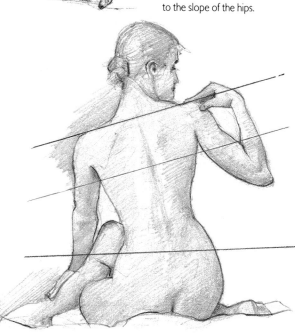

▲ **Backstage** Douglas Lew, *watercolour*
The key to capturing the action of a pose is to observe closely, decide what is most important and commit it immediately to paper. Sometimes a perfect anatomical drawing is less appropriate than an intuitive, freely-drawn image that distils the essence of the pose.

Idle Time Douglas Lew, *watercolour*
Here is an example of the use of contrapposto (see also page 77). The right leg is straight, while the left leg is slightly bent; the angle of the pelvis and the head oppose the angle of the shoulders; and the left side of the torso is extended, while the right side curves inwards. This play of opposites transforms a potentially static pose into a dynamic one. Think about this when you are painting portraits – encourage your sitter to strike a relaxed but "active" pose.

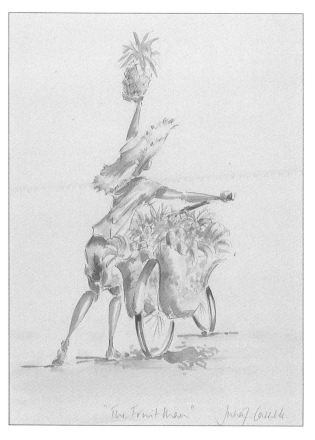

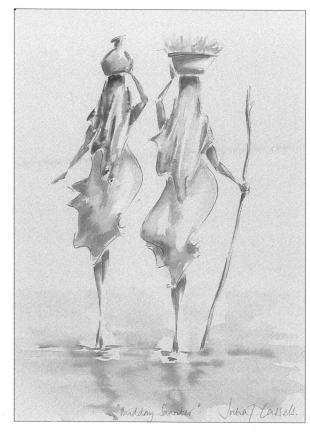

▲ **The Fruit Man;**

▲ **Midday Saunter;**

▶ **Oranges, Oranges** Julia Cassells, *all are watercolours*
The flexibility and natural grace of the human body are captured in these watercolour sketches with tremendous brevity and wit. The emphasis is very much on the gestures of the figures as they balance their loads with such apparent ease, and the lively, calligraphic brushstrokes add to the sense of movement and rhythm. Studies of this type demand an intuitive feel for the rhythms inherent in the human form that can only come from a thorough knowledge of drawing.

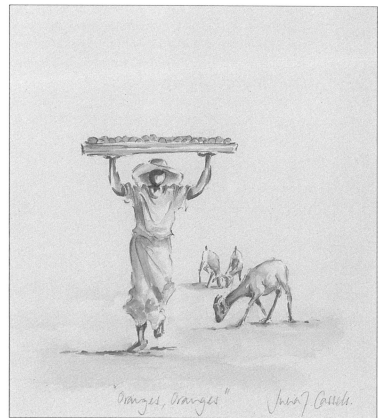

Q & A
MOVING FIGURES

What techniques should I use for giving a sense of movement to my figures?

Before starting to draw a moving figure, it is important to spend some time simply observing your model. Try to feel the overall rhythm of the figure's movement and to understand how it works. Mimic the motion yourself in order to experience the way in which the balance of the body changes at different stages of the action. When you feel ready, make some quick sketches. Try to capture the main actions in just a few lines. Do not worry about detail, but be loose in your sketching, using fluid arm movements rather than working tightly. As you sketch, you will find that you develop your own shorthand of quick strokes and lines that "catch the movement".

While watching your subject, you will notice that certain phases or positions within the movement are more active than others. In a walking figure, for example, the point at which the leading foot is about to hit the ground and the other foot is about to lift is the peak moment of the action, and carries its own inherent momentum. If you can capture this peak moment in a stride, a kick, a swing or a reach, your figures will always have energy and life.

The lines and strokes used in a painting or drawing can also generate energy and achieve the desired impression of

The Green Cyclist Douglas Lew, *watercolour*
When we watch a subject moving at speed, our eyes do not register precise details but a blurred impression of shape and colour. Douglas Lew harnessed the fluidity of watercolour for this impressionistic study of a racing cyclist. He worked rapidly wet-in-wet, keeping the surface damp almost to the end and avoiding sharp edges; the sense of speed is enhanced by the streaks and blurs of the paint.

Zanzibar Women Julia Cassells, *watercolour*
Using swift calligraphic brushstrokes, Cassells captures the languid elegance of these African women walking across the desert. Watercolour's fluidity and immediacy make it an ideal medium for targeting a moving subject.

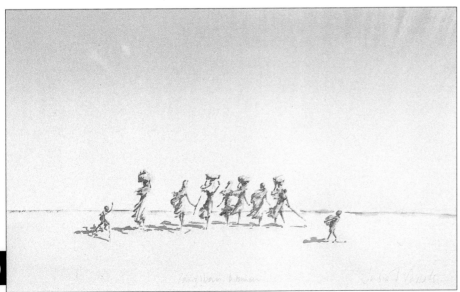

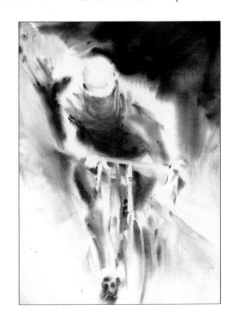

The Coconut Beat Julia
Cassells, *watercolour*
When depicting a moving figure,
try to "freeze" the action at or
just after its peak. In this study,
Cassells depicts the figure at the
point just after the stick has
reached the point of rest
between swinging back and
coming forward. This position
gives the greatest feeling of
energy and motion because it
implies forward movement.

▼ **Ronnie in the Air** Carole
Katchen, *pastel*
Here, the pose of the leaping
dancer conveys a strong sense
of movement arrested in mid-
air. All non-essential details are
eliminated which serves to
emphasize the energetic outline
of the dancer.

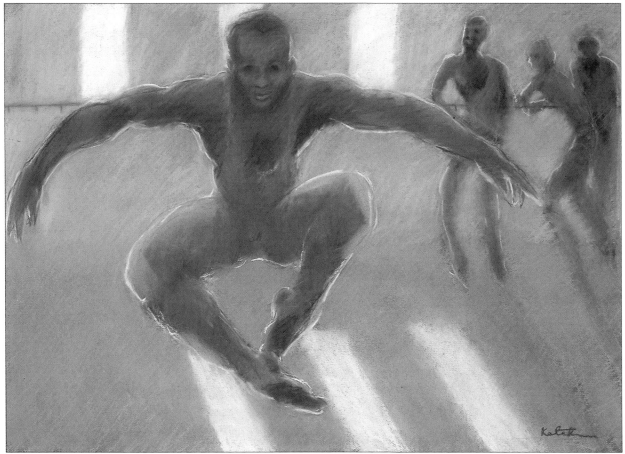

movement. When sketching the figure, use the restating method. A single mark outlining a leg will make it look static, but a series of lines will give the impression of change. When painting, apply washes freely to create the "blurred" impression associated with movement.

The composition of a picture is another important factor in accentuating movement. For example, in capturing the exciting atmosphere of a group of athletes racing towards the finishing line, you might choose a head-on viewpoint that propels the viewer straight into the action.

ART SHOOL

. .

GESTURAL DRAWING

When drawing moving figures, most of us tend to stiffen the pose, so that instead of a living, breathing person we end up with a cardboard cut-out! To capture the grace of the human form in action, learn to draw with a loose, fluid action that captures the essential *gesture* of the figure.

Gestural drawing involves using fast, scribbled strokes to capture the rhythm and gesture of your subject as quickly as possible. The aim is not to reproduce the *form* of the figure, but to convey its *movement*.

Take your sketchbook to your local sports centre, bowling alley or swimming pool. Failing this, get a friend to pose for you, altering the pose every two minutes. This forces you to capture the essential gesture of the pose. Gradually reduce your sketching time, until you can encompass the entire pose in ten seconds. Use a sympathetic medium – soft pencil, charcoal or felt marker pen. As you draw, allow your hand and arm – in fact, your whole self – to respond to the subject. Keep your pencil moving all the time, hardly lifting it from the paper, freely following the movement of the subject.

Do not start out with the intention of producing a "good" drawing, but make several sketches on your paper. Gestural drawing is like limbering up before an exercise routine. You will soon begin to warm up and to "feel" the gesture in such a way that you can transpose it to the paper without hesitation. You need only to glance at your paper, but it is important to look at your model constantly.

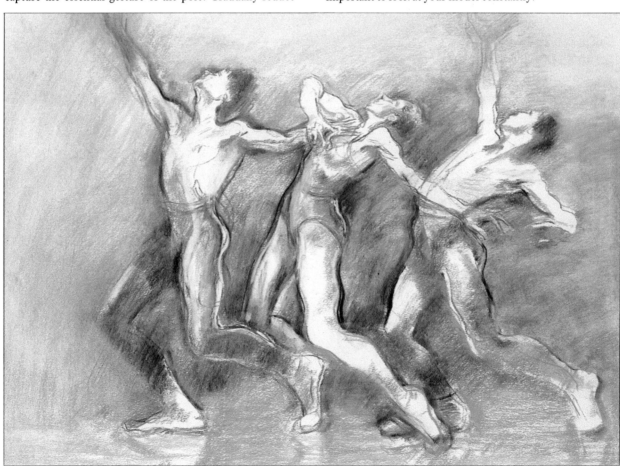

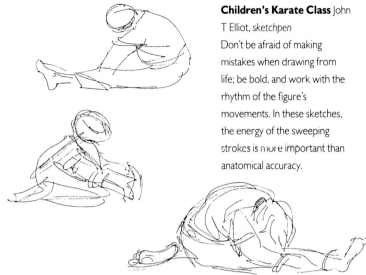

Children's Karate Class John T Elliot, *sketchpen*
Don't be afraid of making mistakes when drawing from life; be bold, and work with the rhythm of the figure's movements. In these sketches, the energy of the sweeping strokes is more important than anatomical accuracy.

◀ **3 Dancers** ▲ **3 Purple and Green Figures**
▶ **Ethnic Dance** Brenda Godsell, *charcoal and pastel*
These drawings of dancers are a perfect example of how gestural drawing conveys a sense of movement. Godsell moves her pastel and charcoal sticks in, through and all around the gestures of the figures. The combination of swirling lines and smudged tones creates its own energy, and captures the essence of movement rather than freezing it.

Dancer Relaxing Brenda Godsell, *charcoal*
This drawing illustrates the fluidity and movement inherent in the human figure, even in repose. Godsell conveys the body's full weight as the dancer relaxes into the floor by varying the charcoal strokes.

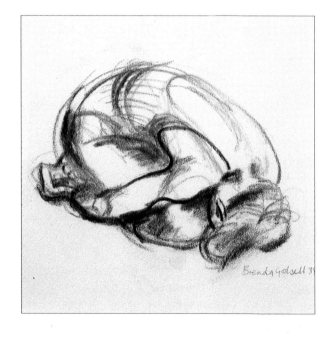

FORM AND VOLUME

My figures look flat and one-dimensional. How can I make them more realistic?

The most important factor to bear in mind when painting a portrait or figure is not that you must get the mouth or the hands right, but that there should be an accurate evaluation and placement of tonal values – in other words, of lights, darks and mid-tones. When painting the figure, you are not painting eyes, nose, arms and legs, but rather the effect of light striking these forms. This is an important point that beginners find difficult to grasp at first. It is not the form itself, but the play of light and shadow on that form, which helps us to identify its shape and character.

It is not possible to create three dimensions on a two-dimensional surface, so the artist must use his or her skill to create an "optical illusion" of form and solidity. This is done through a combination of tone, edge control and line quality, so let's examine each of these in turn.

Tonal values

In rounded objects, such as those that make up the human form, the tones of light and shade must be carefully modelled by following the curves of the various surfaces as they turn from the light. This range of tones can be divided into six main degrees of intensity, as described below.

Light planes are those that face squarely to the main light source.

Halftone defines those planes that are tilted at a slight angle to the main light source.

Shadow refers to those planes that face away from the light source and receive little or no light.

Reflected light appears when a measure of light bounces back into the shadow, either from a secondary light source opposite the main source or from an illuminated object nearby.

Highlight – this is usually the strongest light and appears where a shiny or reflective surface, such as the eye, reflects back the original light source.

Cast shadow – a shadow cast by one plane on to another is usually darker than a normal shadow because it is not lightened by any reflected lights.

Line and Form

The figure studies on this page demonstrate how line, as well as shading, can be used to describe form. By varying the pressure on the pencil, the artist produces graceful, curving lines – now "lost", now "found" – that follow each subtle change in the contour of the figure.

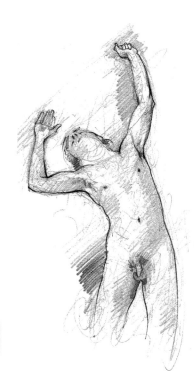

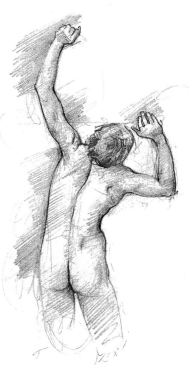

Ball-point lines

This line drawing was made with an ordinary ball-point pen. The lines, which disappear in places, succinctly describe the form of the figure.

▶ **Hatched pencil line**

Here, the play of light on the muscles of the model's back is described more fully, the tones being built up with a series of finely hatched pencil lines.

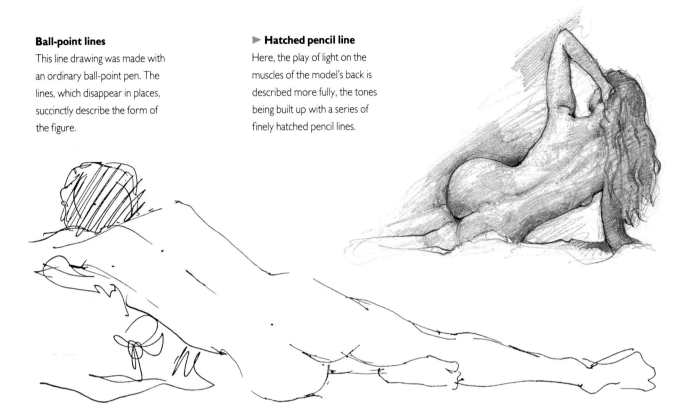

When painting or drawing, never judge a tonal value in isolation, but always consider it in relation to the values surrounding it. Mentally establish the lightest and darkest points on the figure and see how the other areas fall into place between these two variables.

Always work from the general to the specific. First establish the main areas of light, halftone and shadow, and then begin to refine them by increasing the range of halftones. At the same time, be selective; a strong, simple tonal range is more effective than a complex, fragmented one.

Finally, remember that the human face and body are made up of extremely subtle forms and shapes. There are no abrupt edges; instead one form blends gradually into another, and you must therefore pay special attention to halftones. If there is too abrupt a jump from a light to a shadow, the figure will begin to look like a map that has been filled in with different colours for each area. If you want to go from a very light to a very dark tone, use three or four halftones between the two to lead the eye gently from one extreme to the other.

Edges

A contour is affected by the way light falls across the form, obliterating some edges and defining others. The "lost" and "found" edges of the outline indicate its volume. The human face, for example, is a complex mass of hard and soft edges. Bony areas, such as the bridge of the nose, appear harder than the soft curves of the cheek. Similarly, the light-struck contours of the face and body may appear well-defined, while the contours on the shadow side are much less clearly defined. It is important to learn how to handle these edges, because this skill offers an effective way of conveying the illusion of form and solidity on a two-dimensional surface. In addition, the interplay of hard and soft edges lends beauty, character and sensitivity to your painting.

Line quality

When drawing the figure, try to "feel" the contours as you draw them. It may be a helpful exercise to imagine the page as a piece of clay from which you model form by pushing and pulling (exerting varying degrees of pressure on the pencil). Start with light strokes, and then exert more pressure along those contours that you wish to emphasize, such as the outward curve of the calf muscles, hips and buttocks. As well as conveying a sense of life and animation, the resultant contrast between these strong active contours and those passive ones that are lightly drawn helps to create the impression that the shape continues behind the image you have drawn.

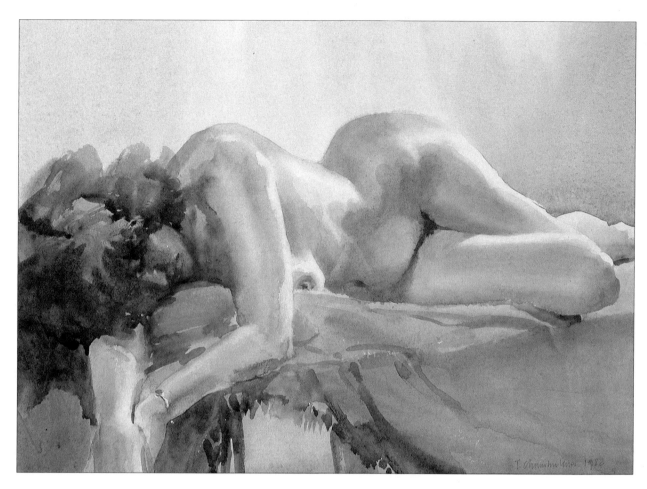

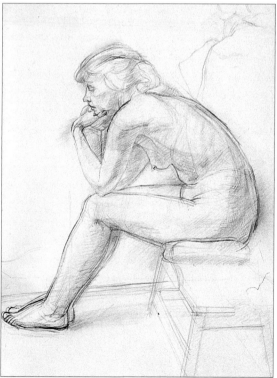

▲ **Reclining Figure** Trevor Chamberlain, *watercolour*
Delicate, transparent and fluid, watercolour is the ideal medium for painting the human form. With a masterly touch, Trevor Chamberlain uses a combination of wet washes and crisp-edged glazes to structure the rounded and bony parts of the figure. Shapes and volume are modelled with warm and cool colours.

◀ **Life Drawing, Royal College of Art** Stephen Crowther, *pencil*
In this study, Crowther varies the strength of the pencil outline to convey an impression of solidity. The emphasis given in certain areas, such as the shoulders and back, gives a vivid sense of the model's weight on the chair. The shadows on the face and body are modelled with hatching and shading.

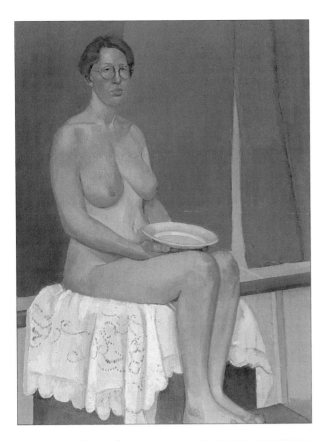

▲ Nude with Spectacles
Alison Watt, *oil*
This artist uses almost
monochromatic colours,
extremely subtle gradations of
tone and a smooth, highly
finished paint surface to give her
figures a solidity and
monumentality almost akin to
sculpture.

A Life Study Clifford Hatts,
OBE, *pastel*
The interplay of crisp lines and
accents, made by hard pastels,
with the broad strokes of soft
pastels is very effective here in
conveying the form and
modelling of the figure. The dark
tone of the paper shows
through the applied pastel
colours, and has a unifying effect,
serving to integrate the lights,
darks and mid-tones.

▲ Afternoon Light Stan
Smith, *charcoal*
This drawing shows the emotion
and feeling that can be
expressed when strong
contrasts of light and tone are
employed in a drawing. This was
made in charcoal, using the point
and the side of the stick to
produce both lines and tones.
The light paper is left untouched
to indicate the highlights on the
figure, which give the drawing its
dramatic impact.

·········· Q & A ···········
STANDING FIGURES

When I draw standing figures they look stiff and wooden. How can I correct this?

Sketchbook page Stan Smith, *fibre-tip pen*
The way to catch the rhythm inherent in a standing pose is to feel the outlines as you draw them. In this sketch, Smith alters the pressure on the pen, producing thicker, darker lines to emphasize the active contours in the two figures, and thin lines to indicate the passive contours. Knowing which muscles are at work in a pose and which are relaxed can help you to decide which surface forms to emphasize. If necessary, copy the pose yourself, and study the effects on your own body in the mirror.

While it is obviously important to get the form and proportions of the body correct when drawing figures, it is equally vital to capture the inherent *rhythm* of the figure and thus inject a sense of life and movement into your work. When this important aspect is overlooked we end up with what Leonardo once rather acidly described as "wooden and graceless nudes that look more like a sack of nuts than a human being".

Do not fall into the trap of treating each form – neck, shoulder, arm, hand – as a separate entity. Instead, think of them as a series of interlocking parts, each connecting with and emerging from the other. As you draw, look at the model's silhouette, and sketch in the outline with broad, free strokes. Do not be afraid to re-assess or correct as you draw, until the various parts of the body flow smoothly from one to the other. Only when you have something resembling the pose should you return to specific areas and tighten them up. Working in this way, from the general to the specific, you can express the flexibility and natural grace of the human form.

As you draw, follow the contours of the body almost as if you were caressing them, and use quick strokes to indicate

Weight distribution
To make standing figures convincing, try to understand the weight distribution in any given pose. Here most of the model's weight is on the left leg; to maintain balance, the leg is not straight but angles under the centre of the figure so that the foot is directly under the head. By drawing a line down the centre of the figure, the various angles of the pose can be more readily appreciated.

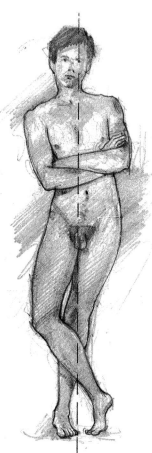

▲ **Peanuts Hucko** Carole
Katchen, *pastel*
This picture was based on
several sketches Katchen made
at a jazz concert. The key to the
success of the drawing lies in the
lively, active gestures of the
figures – note, for example, the
out-thrust right hip of the
foreground player. The nervous,
scribbled lines of the drawing
further enhance the sense of
movement and energy.

▲ **Malay Girl Sweeping II**
Jane Corsellis, *oil*
There is an unselfconscious
elegance in this girl's pose. Her
turned head, upraised arms and
the diagonal of the broom form
a counterpoint to the vertical
axis of her body.

◀ **Green Pail** Sally Strand,
pastel
An awareness of the line of the
body can help to overcome
"woodenness" in figure studies.
Here Strand vividly conveys the
figure's rhythms and tensions.

mass and shadow. Move with your whole arm, not just your fingers, and use your pencil sensitively to feel out the forms. Do not give the same weight to every line; instead, give more weight to the stronger contours – an out-thrust hip, the curve of a calf muscle – than to the weaker, receding contours.

Of course, it is much easier to see and record the rhythm in an active pose, nevertheless even a relatively static standing pose has a subtle rhythm of its own. The angle of the head affects the angle of the neck and shoulders, the stance of the legs affects the hips and torso, and so on. It is essential that you establish the directional flow of the body if you are to produce convincing figure drawings.

ART SCHOOL

· ·

KEEPING A SKETCHBOOK

To my mind, the single most important item in any artist's panoply of equipment is a sketchbook. The more you use your sketchbook the more confident and proficient you will become, so you should aim to draw or paint in it every day. An artist is no different from a dancer, a musician or an athlete: each must practise the techniques of the art and hone his or her skills constantly and diligently in order to achieve success. Besides, for most artists sketching is a true pleasure, something which becomes instinctive, in fact almost addictive. If ever I leave home without my sketchbook in my pocket, I experience the same sense of panic and loss that a smoker feels on discovering that he has run out of cigarettes and all the shops are shut!

Sketchbooks are the perfect place in which to note and record anything of interest, the moment you see it. With a pencil and a scrap of paper you can catch life on the wing – a chance encounter, a fleeting effect of light, a fascinating face. At times like this, a note or two of what you see at a glance, jotted down quickly on a page, may prompt you to turn your sketch into a finished drawing or painting later.

Let your sketchbook become your friend and confidante. You are under no pressure to perform, producing an elegant series of perfect sketches, so do not be afraid to experiment with new ideas or try out different ways of composing your subject. Here, you can take risks; some of your ideas may not work, but you will not know until you try. Some may be excitingly successful, leading you in new directions.

Finally, your sketchbook is a place in which to develop your creative flow and evolve your own individual style through rapid and frequent sketching. As the speed and volume of your work increase, any stiffness in your drawing should disappear, and expressing what you feel and see will become increasingly intuitive.

Over the years, your sketchbook will become a record of your growth and development as an artist – a visual diary that is fascinating to look back on.

Nun and Old Woman
Rosalind Cuthbert, *watercolour*
A long journey by public transport need not be boring if you carry your sketchbook with you. Trains, buses and planes are great places for people-watching, and if you can manage to draw discreetly and catch people unawares, you can produce marvellous character studies like this one.

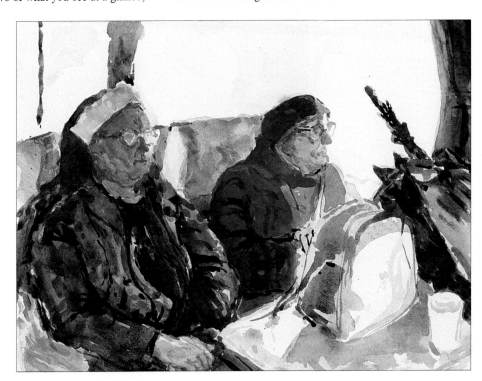

Sketchbook page John Lidzey, *watercolour and pencil*
Watercolour is a useful medium for on-the-spot sketching because it allows you to block in the vital elements of the scene with rapid brushstrokes and overlaid washes of colour. This sketch, for instance, is very impressionistic, and provides a lively interpretation of the subject which could be worked on in more detail in a finished painting back in the studio.

Study of Aram Katchaturian Edmun Aivazian, *pen and ink*
Leonardo wrote of drawing as the equivalent of a rough draft of a poem, all the more fertile for being incomplete. These sketches, rapidly drawn on-the-spot at a classical concert, confirm this view.

Aug.1.87 B29-3

Sketchbook page John Elliot,
pencil
The joy of sketching is that you don't have to worry about producing a perfect, "finished" drawing. This liberation often results in a drawing which, though it may contain some minor inaccuracies, is far more incisive and expressive than a highly finished drawing might be.

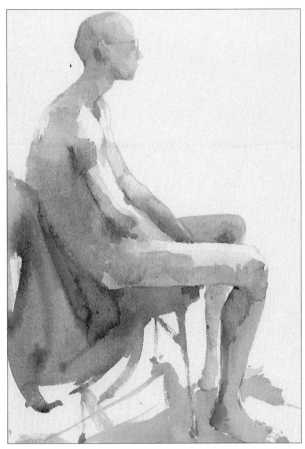

Male Figure Shirley Felts,
watercolour
Though this is a figure study more than a sketch, it nevertheless has that indefinable "lost and found" quality that makes sketches so attractive. An image which suggests, rather than overstates, lives on in the memory for the simple reason that the viewer actively participates in it, supplying the "missing" elements from imagination.

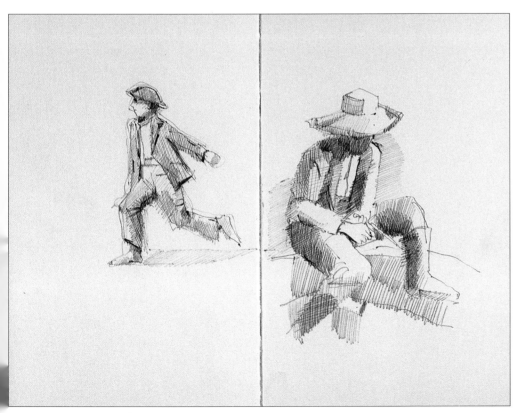

Sketchbook page John Lidzey, *ballpoint pen*
A ballpoint pen may seem at first an unsympathetic medium for sketching, but what it lacks in subtlety and "spreadability" it makes up for in its strong linear qualities. The crosshatched lines used here give these figures a strong sense of solidity.

·········· Q & A ··········
CLOTHING AND DRAPERY

How do I render the folds and creases in fabric and clothing?

▼ Contour drawing

Begin with a contour drawing, loosely outlining the main folds and tonal areas, and then block in the main shadows, using light hatching strokes.

Having worked out the form of the folds, refine the drawing by building up the tones of the shadows and highlights (below right). Screwing up your eyes will help you to discern the subtle differences in tone.

In most portraits and figure studies the face or figure is the focal point, and the model's clothing plays a secondary role. Nevertheless, clothing and background drapery can contribute much to the painting, and are worthy of attention. Fabrics not only echo and accentuate the form and movement of the figure, but their shapes and colours also influence the composition and the tonal balance of the picture.

Drawing and painting folds and creases in fabric may seem daunting at first; so often they fall into complex arrangements that seem to have no clearly defined form. One approach is to begin with a contour sketch loosely outlining the main tonal areas and folds. Use light lines to define the areas of light and shade, and stronger lines to represent the folds of the cloth. Then move on to block in the tones and details.

Patterns appear to add further complications, but a logical approach simplifies the process. Look at the fabric, then divide it into portions related to the way the material falls. Notice how the pattern runs in different directions within

▲ Spiral fold

Practise drawing different types of folds until you understand their structure. A strong directional light helps to bring out the form of the folds more clearly. A rolled-up shirt sleeve forms a spiral of loosely compressed folds. These may appear complex, but there's a set procedure for drawing them, as shown below

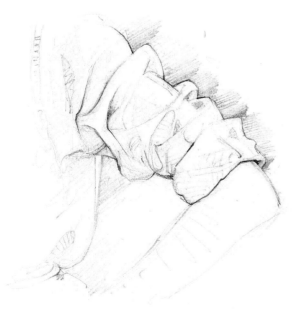

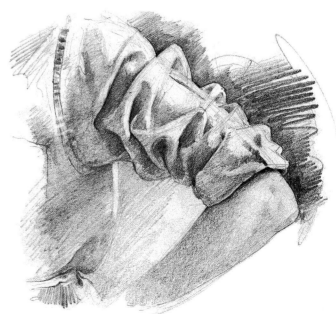

Rendering fabrics

It is worth experimenting with a range of techniques and media for rendering the patterns and textures of different fabrics. These are just a few examples to try out.

1 Denim Using a dry brush, vertical strokes of blue are overlaid with diagonal strokes of thin white paint.

2 Tartan pattern Transparent washes are applied wet-over-dry.

3 Tweed Black carbon pencil marks are drawn on rough paper.

4 Silk The shadows are created with finely hatched strokes of soft crayon, leaving the bare white paper for the highlights.

5 Corduroy Vertical strokes of carbon pencil and pastel pencil are drawn on rough paper.

6 Paisley pattern Watercolour washes and strokes are made with a finely pointed brush.

▼ **Clothes and action**

It is a useful exercise to make sketches of figures engaged in some activity. Observe how the body affects the shape of the clothes and, conversely, how certain clothes (for example winter clothes) are often restricting and tend to make the body alter its pose and movements.

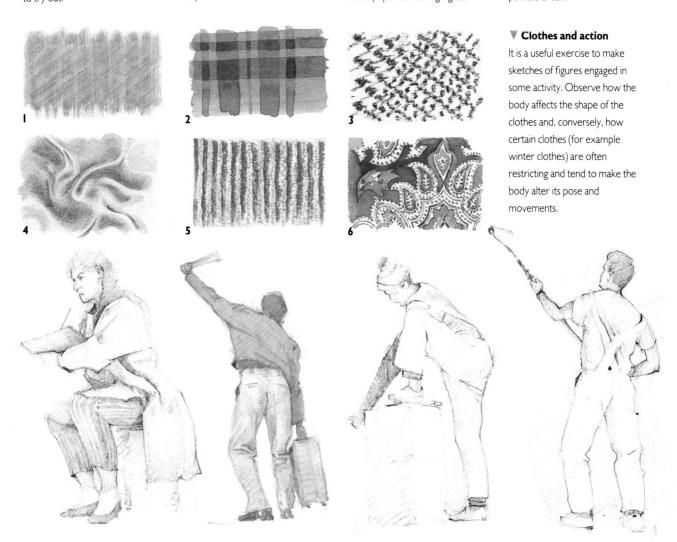

each section. Determine the shadows and highlights and mix three tones of each colour. Use the lightest tones for the highlighted fronts of the folds, the mid-tones for the areas where the folds start to turn back, and the darkest tones where the folds are in shadow.

It is not always necessary to include every pattern detail; instead, you will find that it is often more effective to suggest the pattern rather than attempting a precise study.

Remember that the weight and thickness of a fabric influence the way in which it falls over an object. Soft fabrics, such as wool, silk and thin cotton, generally reveal the contours of the underlying form and create many folds that catch highlights and shadows. Thicker, stiffer material, such as that used for men's suits, forms broad, heavy folds that reveal only a vague outline of the underlying forms.

When drawing and painting clothing, be sensitive to the structure of the forms of the body that lie beneath. Be selective and record those folds and lines in the fabric that reveal the shape and characteristic stance of the figure, and omit or subordinate those that might obscure or confuse.

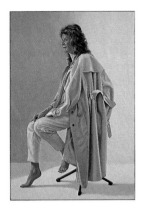

▲ ▶ A Barefoot Redhead
Walter Garver, *oil*
Here, an interesting
arrangement of folds in the
model's clothing provides
textural interest, and the strong,
sweeping patterns also direct
the eye to the model's head and
counterbalance the fine detail of
her hair and skin.

In the detail, *right*, you can see
that Garver's technique involves
starting with a thin, randomly
applied underpainting which
shows through the final layers of
paint and describes the subtle
fluctuations of light and shade
found in the cloth. Yellow does
not mix well with blacks or
browns, so Garver first paints
the shadows on the jeans with a
warm grey, and the dark folds
with brown. When this is dry he
then glazes over the shadows
with a semi-transparent layer of
cadmium yellow deep and
Naples yellow. Because the
yellow glaze does not mix with
the underlayer, it becomes a
darker shade without turning
muddy or flat.

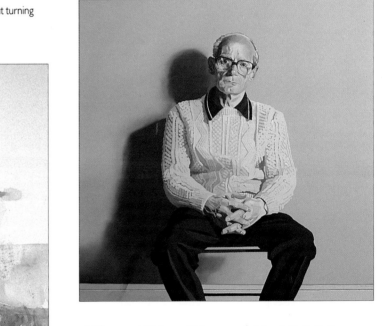

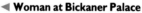

◀ Woman at Bickaner Palace
Clarice Collings, *watercolour*
In this lively and spontaneous
study, Clarice Collings is not
concerned with literal detail, but
with the overall impression of
the figure swathed in yards of
gorgeous golden silk.

▲ The Artist's Father
Ian Sidaway, *oil*
In contrast to Clarice Collings'
free and rapid study, *left*, Ian
Sidaway adopts a more graphic
and methodical approach. The
texture and pattern of the Aran
sweater is given careful
attention, but at the same time is
not overstated.

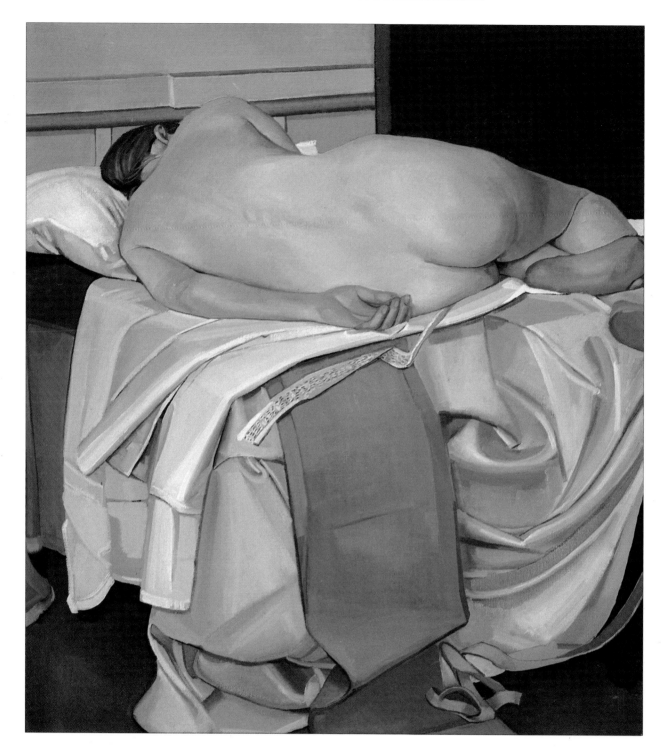

Sleeping Nude Alison Watt,
oil
Drapery, creased and folded, is
a fascinating subject for the study
of line, form, light and shade. In
this painting, the draped sheet
dominates the composition, its
precisely defined folds
contrasting with the soft forms
of the figure.

Q & A
DOUBLE AND GROUP PORTRAITS

I'd like to tackle a group portrait. How should I go about it?

A portrait featuring two or more people is certainly a challenge. Let's face it, painting an individual portrait is difficult enough; but on the other hand, to tackle a double or group portrait can prove an absorbing and rewarding experience, because it offers you so many opportunities to use your creativity. With a family group, for instance, the challenge lies in arranging the figures in a way that is both natural and aesthetically pleasing; in conveying the implied relationship between the members of the group, and in choosing a background setting that will complement, but not overwhelm, the group.

Thorough planning and preparation are essential to the success of a group portrait. If possible, get the group together for a dress rehearsal a few days before you start the actual painting. This will give your sitters a chance to warm up and to practise posing naturally before the big day, and will allow you to start planning the picture. Make as many preliminary sketches as time allows, and take reference photos if you like.

There is a lot to think about – not only the arrangement of the group and their individual poses, but also the background and props, the lighting and the colour scheme. The clothing worn by your sitters also requires consideration: if you have three or four people wearing clashing colours, it is not going to do a lot for the colour harmony of the finished portrait!

You may find that your sitters adopt stiff and awkward poses because they feel self-conscious. This may be tiresome, but for goodness' sake refrain from bullying your clients – you are not a wedding photographer! Simply ask the group to relax together and feel at ease while you pretend to fiddle around with your paints or whatever. You will find that they relax and adopt more natural poses and expressions, and the group as a whole will form a cohesive unit without having to try. Having said that, it is as well to watch out for, and correct, awkwardly placed hands, arms that hang limply and background objects that appear to be sticking out of someone's head.

If you have three or four people wearing clashing colours, it is not going to do a lot for the colour harmony of the finished portrait!

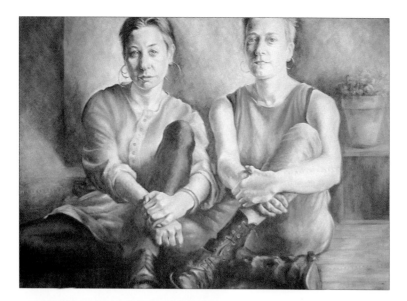

Sally and Sam Jacqueline Hines, *oil*
When two people are in tune with each other, they unconsciously mirror each other's body posture. In this portrait of two friends, the similarity of pose conveys a sense of closeness.

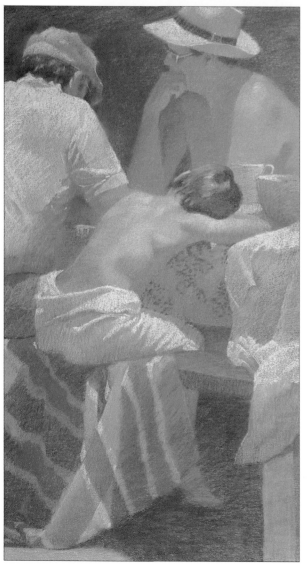

Played Out Sally Strand, *pastel*
Strand's figure compositions are always natural and unposed, presenting a slice of life which arouses a sympathetic response in the viewer. Here, the closely cropped composition focuses our attention on the arrangement of the figures.

But . . . I Know What I Like
Linda Atherton, *oil*
Group portraits often work better when the subjects are doing something, rather than obviously posing for the picture. This painting of an art class has an air of informality and spontaneity, with the subjects engrossed in their discussion of the picture on the wall.

Tea in the Studio Linda Atherton, *oil*
Everyday scenes of family and friends relaxing together make enjoyable and rewarding subjects to paint.

▶ **Conversation at the Rose Café** Carole Katchen, *pastel*
In this picture, the artist gives emphasis to the body language of two figures deep in conversation.

▼ **Taking the Daily** Sally Strand, *pastel*
Each of these figures is an interesting study in itself, yet together they form a cohesive group, stabilized and connected by the horizontal lines of the park bench.

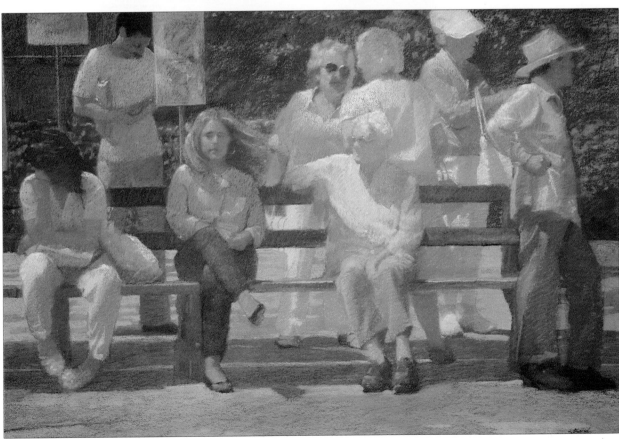

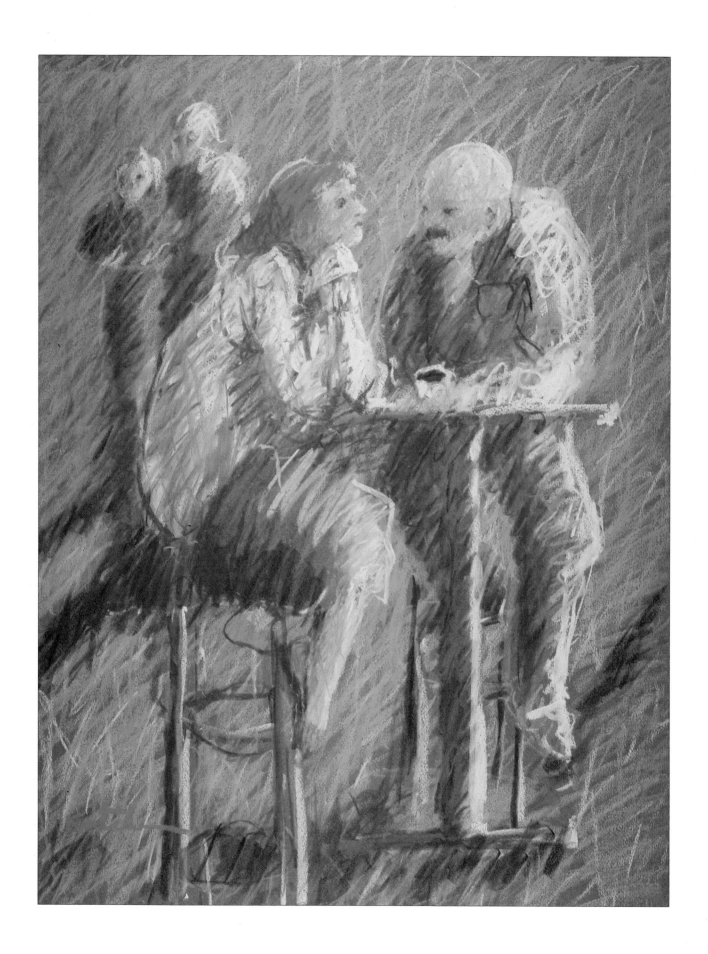

LEARNING FROM THE
MASTERS

DEGAS

Degas' early work was firmly rooted in the classical academy traditions of strong draughtsmanship and organized design (his revered master was Ingres). He later fell under the spell of the Impressionists, however, though he always hotly denied being one himself, and his daring compositions were influenced by the new techniques of photography and the Japanese print. Thus his work combines the discipline and order of classical design with an impression of life that is immediate and spontaneous. The nude was a central subject in Degas' art. *The Tub* is typical in that it is a frank and uncompromising portrayal of a woman at her toilette, yet at the same time Degas has invested the image with a strong humanitarian quality.

Degas was a consummate draughtsman and described himself as "born to draw". This detail from *The Tub, left,* demonstrates the sureness of line which enabled him to depict the human form with utmost precision, yet at the same time to imbue the drawing with poetry. Degas did not treat the nude as an idealized thing of beauty, but primarily as a vehicle for his study of the structure and articulation of the human form, the rhythm of the body's contour and the play of muscles beneath light-struck flesh. Degas' acute power of observation were based on a lot of practice. He never forgot the advice he was given early in his career by Ingres: "Draw lines, young man, plenty of lines."

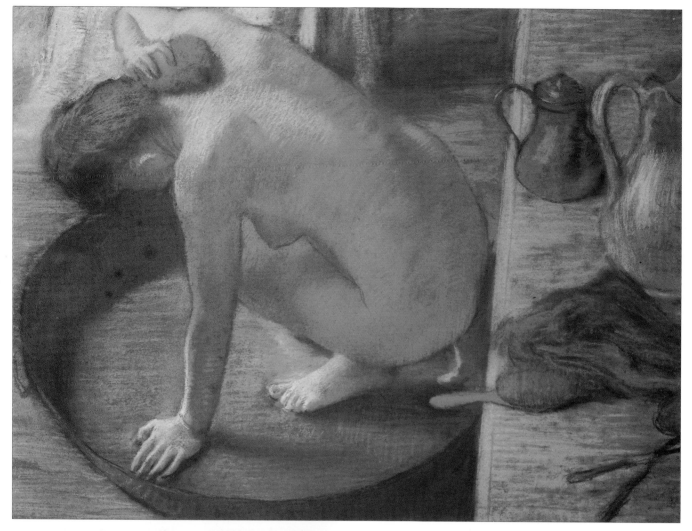

A great innovator of the pastel medium, Degas was one of the first to use broken colour. He worked with open, webbed layers of pure colour which allowed glints of the earlier colours to show through, and he often juxtaposed complementary colours, or warm and cool colours, to create tension and vibrancy. This detail, *left*, shows how the soft, friable pastel pigment catches on the textured paper, creating a striated, flickering effect between the layers of alternate dark and pale colour which accentuates the play of light on the model's back.

▲ **The Tub**, 1886 *pastel*
61cm × 83cm (23in × 32in)
Musée d' Orsay, Paris

In his later years, Degas made endless studies of women washing, grooming or dressing themselves. He described the subject as "the female, absorbed, a cat licking herself" and his subjects are anonymous, unposed and unidealized. This study shows the influence on Degas' work of Japanese colour prints, with their tilted perspective and off-centre compositions. The "snapshot" sense of naturalness underlines the sense of intimacy.

········· Q & A ··········

FIGURES IN CONTEXT

I like to include figures in my landscapes, how can I get them to blend in naturally?

There is no doubt that figures can make or mar a landscape painting. Handled skilfully, they can provide a focal point in the composition and give an indication of scale. And, as artists such as Turner and Constable knew, signs of human activity can bring to life an otherwise empty landscape. On the other hand, I have seen many a landscape painting ruined by figures that seem to have been added as an afterthought: although the landscape painting itself may be fresh and direct, the figures appear stiff, awkward and tight, or look as if they have been plonked in the middle of the picture for no apparent reason, rendering it trite and sentimental.

Think carefully about the positioning of the figures in your landscapes. They should be an integral part of the overall design. For example, they can be used to stress the importance of the centre of interest, or to lead the eye into the picture. One common mistake which you should avoid at all costs is to paint the figures so tightly that they appear to have been pasted to the background. People rarely stay still for long, and they do not hold themselves stiffly, so it is a mistake to concentrate too closely on figures. Try to draw or paint loosely, and with the minimum of detail. In fact, the less detail you include the better, because the more casual approach will allow a figure to blend naturally with its surroundings, instead of sticking out like a sore thumb.

To develop your confidence, go outdoors and sketch people as often as you can. Find a suitable location where people tend to congregate and linger, such as a café, train station, museum or art gallery. Keep your sketches small and simple. Speed is of the essence, so aim to grasp all the essentials – the overall shape, the posture and the *action* of the figure – at first glance. Either a brush and ink or watercolours are ideal, allowing you to capture the outline rapidly in just a few strokes. You may end up with a sheet full of half-finished attempts, but even if only one of these contains some of the elements you are seeking, the effort will have been worth it, and your sketches will stand you in good stead as reference material for later work.

Think carefully about the positioning of the figures in your landscapes. They should be an integral part of the overall design.

Figures in landscapes
When sketching figures in the landscape, look for the essentials of gesture and stance, and keep your drawings simple; don't invent but observe.

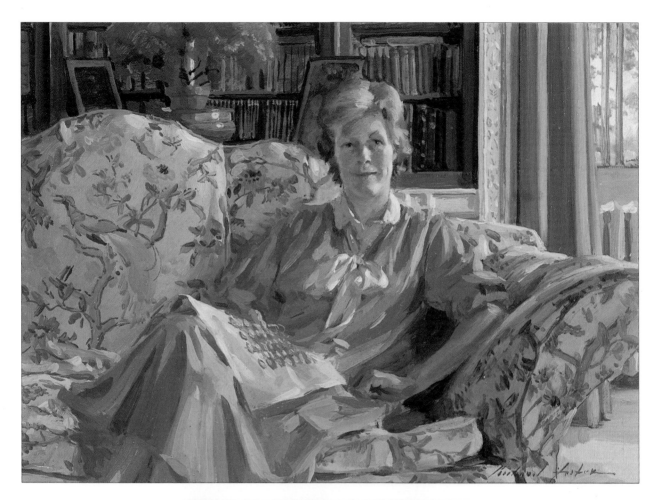

▲ **Lady Wake** Richard Foster, *oil*
When you include a background
in a portrait, consider the colour
relationships between the model
and the surroundings. For
example, the colours and
textures of the clothing should
be considered as carefully as all
other aspects of the painting. In
this picture, the warm pink of
the sitter's dress is echoed in the
sofa, the curtain and the potted
plant, and is softly reflected in
her skin, thus enhancing the
mood of warmth and intimacy
as well as creating a good,
harmonious composition.

◄ **The Ghats at Udiapur** Tom
Coates, *oil*
The most usual setting for figure
studies is in the relatively
confined space of a room or a
studio. Sometimes, however, it
can be exciting and instructive to
attempt a much larger setting.
Here, the figures are painted
impressionistically, yet they are
convincing because the artist has
a sound grasp of the structure of
the human body, and has
captured the essential gestures
of the figures.

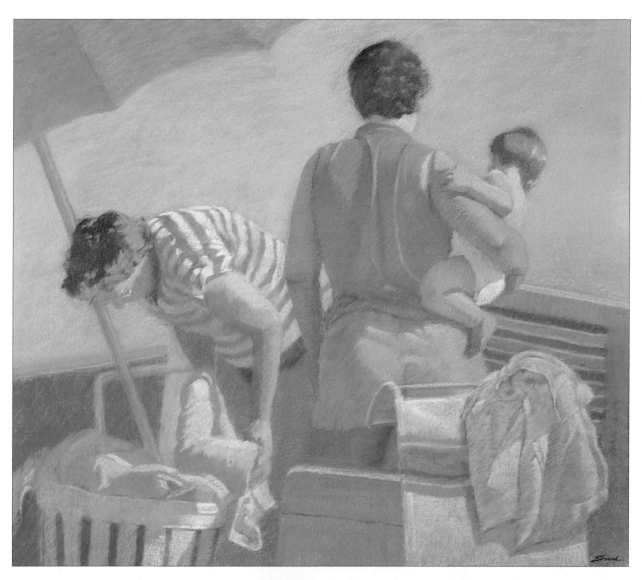

▲ **Getting Comfortable**

Sally Strand, *pastel*

The beach is an excellent place
to find cameos such as this, in
which people going about their
ordinary business reveal an
unselfconscious attitude of
grace which has great
expressive power.

Lazy Day, Summer 1989
Trevor Chamberlain,
watercolour
With great economy of means, Chamberlain has conveyed the play of dappled light on the figures. Much of the poetry of a painting is attained by introducing "lost" and "found" areas, to leave something to the viewer's imagination; compare the sharply lit background figure, for example, with the two central figures veiled in shadow.

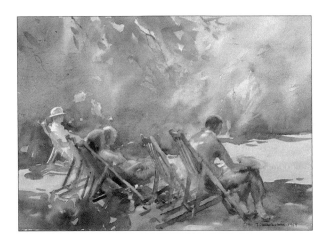

Beggar, Happy Valley, Hong Kong Stan Smith, *mixed media*
In this lively sketch, pencil and ink lines and bravura watercolour washes capture the bustle and noise of a downtown marketplace. Despite its busy impression, the composition is well ordered; the foreground figure forms the central axis of the image, and the riot of colour is organized with a dominance of red and yellow.

◀ **San Marco, Venice** James Horton, *watercolour*
Don't be over-concerned with detail when painting incidental figures; here, the artist has used a shorthand of strokes and dabs to create the impression of the crowd in the background.

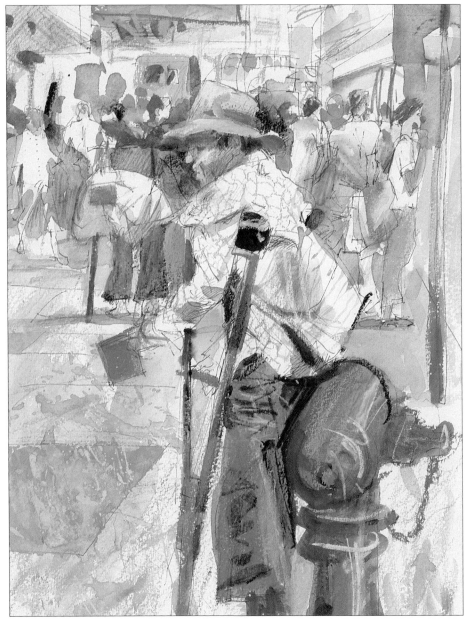

JOHN RAYNES
FIGURE STUDY

Figure study in Conté pencils

For this figure study, artist John Raynes used coloured Conté pencils, which are Conté crayons in pencil form. The advantage of this medium is that the pencils can be used in a linear way for a graphic effect, or they can be smudged for a more painterly effect. The palette of colours consists of siennas, flesh tints and warm and cool blues and greens.

However good your model is, he or she may move and you should be ready to alter things as you go along. If it is immovable, a drawing comes to a standstill; drawing is a process of correcting errors, and when there are no errors left to correct, the image is complete! In this demonstration, the artist works over the image lightly, layer by layer, leaving the underlying tone of the paper to show through between the strokes, and producing a lightly-textured, delicate finish.

▲ **I** The artist begins by sketching the overall shape of the figure and chair with a light brown pencil. At this stage he is finding the "architecture" of the composition, so the lines are lightly drawn to allow for corrections later.

▲ **2** Raynes continues plotting the "scaffolding lines" of his subject, using colours which approximate to those in the skin tones and clothing, but applied very lightly so that he can build up the darker tones later without clogging the surface of the paper. At this stage, the drawing should not be fixed and immovable, but capable of changing radically if necessary.

▼ **4** Drawing foreshortened legs often causes problems, and the thighs tend to become too long because we draw them as we know them to be rather than as they actually appear. The secret is to draw the shape that's there, no matter how nonsensical it may at first appear.

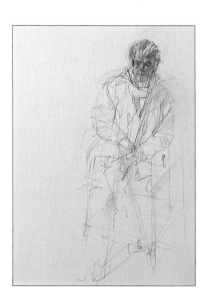

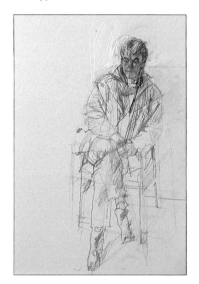

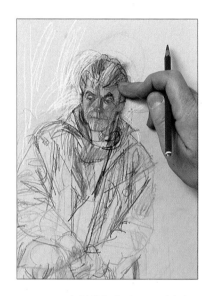

▲ **3** The planes of the face, *above*, are modelled with tones of warm sienna. As he draws, the artist constantly relates shapes and volumes to one another rather than drawing one part in detail and then moving on to the next.

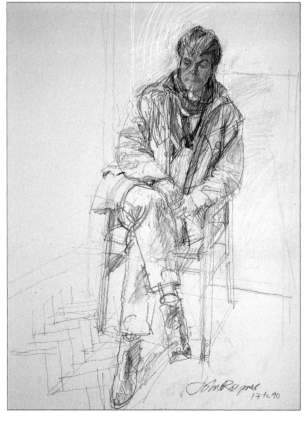

▲ **5** While the figure and chair are rendered with sketchy lines, *above*, the head is more fully modelled, giving it more emphasis as the focal point of the picture. Some of the pencil hatching is blended with a fingertip, and softer pastel sticks in flesh tone are used for the highlights.

◄ **6** Raynes completes the drawing by further intensifying the colours in the clothing and indicating the plane of the floor. The cool grey of the paper is a dominant element, serving as the lightest tone and also breathing air into the drawing. The picture is fixed only lightly, so as not to darken the colours too much.

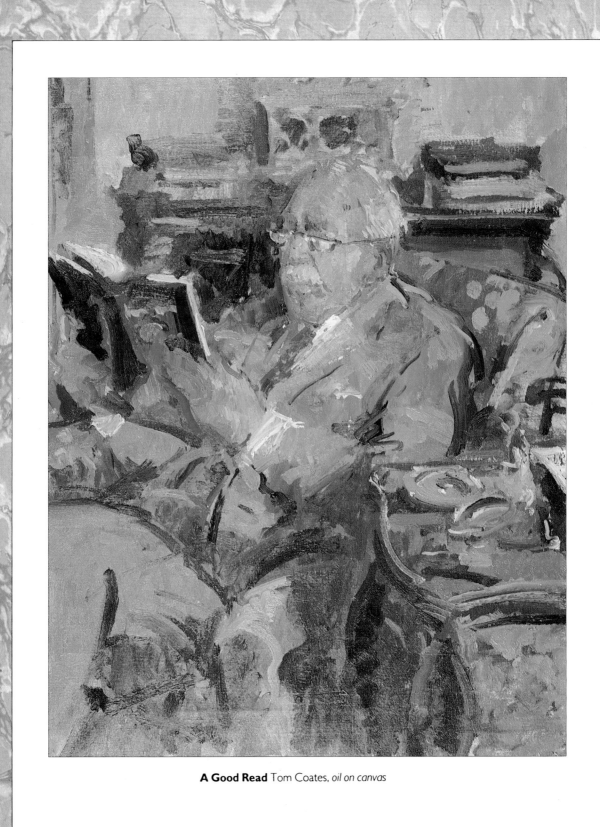

A Good Read Tom Coates, *oil on canvas*

PART 3

· ·

MAKING THE PICTURE WORK

· ·

"A PAINTING NEEDS AS MUCH FRAUDULENCE,
TRICKERY AND DECEPTION AS THE PERPETRATION
OF A CRIME"

EDGAR DEGAS

COMPOSING THE PICTURE

· ·

What are the "rules" of good composition?

There would appear to be 1,001 "rules" concerning composition, many of which are based on mathematical laws handed down from the Renaissance. These make a fascinating study in themselves, as long as you remain aware that a lot of artists have flouted the rules and got away with it, producing memorable pictures. The best rule of good composition is that it should look right to the eye, with the subject fitting attractively and effectively within the confines of the picture surface.

This is not to say that composition is not important, however. Composition is always the principal element in any drawing or painting, no matter how simple it may be. If you plunge headlong into a painting, focusing on the parts rather than the whole, it is like missing the forest for the trees. The artistic worth of your picture depends on the relationships of pattern, rhythm, space, balance, colour and tonal values, all of which should add up to a balanced and satisfying design.

So before you start painting, step back and evaluate the subject and setting as a series of purely abstract forms and try to ensure that they will fit together to create a unified whole. When you select the model's pose, notice the total shape formed by the body – the silhouette. Next, consider where you want to position that shape on the canvas or paper. In doing this, you create other shapes – the "negative" background shapes that are the spaces around and between the "positive" shapes of figures and objects. The background of a portrait is not an empty area where nothing happens. Think of it as a form in itself, which can be used as a counterbalance to the shapes made by the sitter's face or figure. The composition of a picture is much more effective when the positive and negative shapes combine to create interesting shapes and patterns.

Every good composition has a strong focal point, the spot that holds the viewer's attention. The focal point is often the model's face, but it can be any part of the body that you wish to emphasize. One way to emphasize the focal point is by introducing more detail, or stronger contrasts of tone, colour or line in this area, while slightly reducing detail and

The best rule of good composition is that it should look right to the eye, with the subject fitting attractively and effectively within the confines of the picture surface.

▶ **Sunshine Stakes, Weymouth** Arthur Maderson, *oil*
Here is a beautifully rendered painting, expressing a strong sense of rhythm and movement. Notice how the figures on the beach are positioned in a way that moves our attention through the picture; starting with the foreground figure, our eye is led in a gently zigzagging fashion by the patterns of light and shadow and by the placement of the figures on the beach, which act like visual stepping-stones. As the eye travels across the picture and back again, we find items of interest in every section of the composition.

contrasts elsewhere in the composition.

To give the focal point maximum visual impact, be sure to place it carefully within the picture space. A traditional method used by artists is the "rule of thirds", a mathematical formula based on the principles of harmony and proportion. Mentally draw lines dividing the picture surface into thirds, horizontally and vertically, and locate the focal point close to one of the points where the lines intersect. For example, in a head-and-shoulders portrait in which the eyes are the centre of interest, you may wish to position the head so that the eyes are about one third in from the edges of the picture.

Another important element in a composition is rhythm.

As in music, rhythm draws the different elements together and gives the composition its distinctive mood and pace. In a painting, rhythm also encourages the eye to move through the picture. You can create rhythm by repeating lines, shapes, colours and values, creating patterns that harmonize the composition while making it more interesting to look at.

In the final analysis, good composition is basically a matter of good taste, and is something that becomes instinctive with experience. Meanwhile, a sound piece of advice is to study paintings that you admire and note how skilled artists have placed the heads, figures, objects and other elements in their compositions.

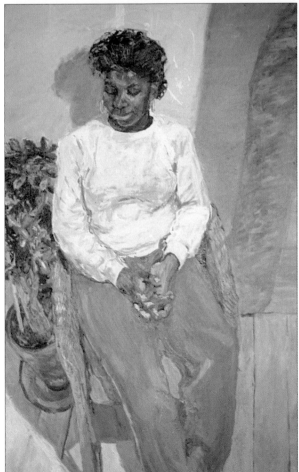

▲ **Day Off** Sally Strand, *pastel*
One way to create exciting figure compositions is to let your subject fill the whole picture space – or even crop it off at the edges, as Sally Strand has done here. By excluding distracting background detail and leaving minimal space around the subject, she gives it greater impact. In effect, we see the picture on two levels: first, as a finely observed figurative drawing, and second, as an abstract pattern of lively shapes – negative and positive – which are emphasized by comparison with the rectangular format of the frame.

Portrait of Sue James Susan Wilson, *oil on canvas*
A high viewpoint tips up the plane of the floor in this picture, creating a strikingly unusual composition. The sitter's inclined head forms a counterpoise with the diagonal line of her body.

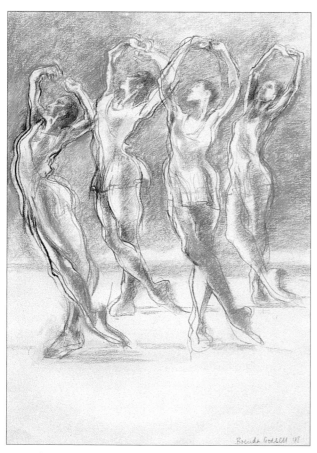

◀ 4 Dancers in Grey Brenda Godsell, *charcoal and pastel*
This drawing is an excellent example of the principle of diversity within unity. The repeated shapes of the dancers' limbs create a strong, unified image, while the subtle variations between each figure create diversity that prevents the composition from becoming monotonous.

▲ Sketchbook page Stan Smith, *pen and ink*
In this open sketchbook, the figures have been drawn with care, but attention has also been paid to their position on the page and to their relationship with each other. The limbs and bodies are arranged to form a single cohesive shape which also has energy, directing the eye in a circular motion.

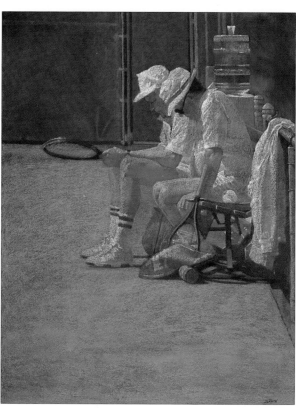

Court Break Sally Strand, *pastel*
Placing a subject off-centre is one of the many ways of creating emphasis in a picture, making the eye go straight to the focal point. Here, the two tennis players are placed close to the edge of the picture, but they are carefully balanced by the expanse of the tennis court. The composition works because of the dynamic tension between rest and movement.

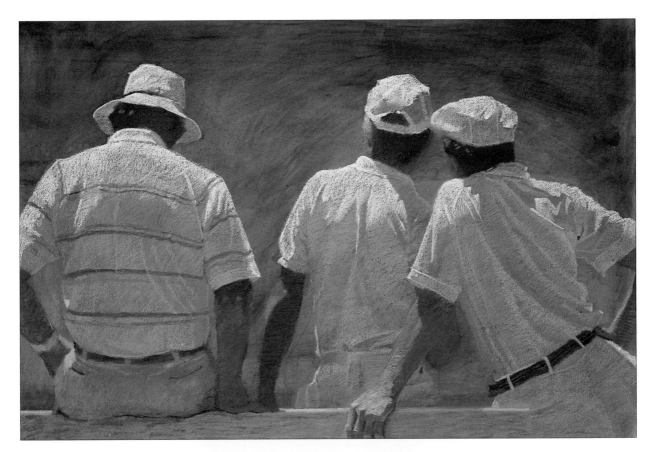

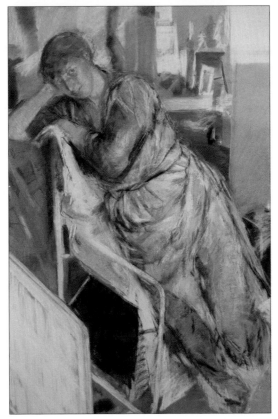

▲ **Men in White** Sally Strand, *pastel*

Repeated shapes, patterns, lines or tones create visual rhythm in a picture – but beware of making them too regular, since this makes for monotony. On the other hand, a rhythmical flow of similar shapes, each with their own individuality, adds spice to a design. In this picture, the three figures unite to form a unified whole, yet at the same time each one is subtly different from the other. The picture is also beautifully balanced, with the broad figure on the left countered by the two smaller figures on the right.

◄ **Kate Fisher and Drapery** Barry Atherton, *pastel*

When deciding on a pose, walk around your model and try out various viewpoints. Rather than accepting the most obvious solution, look for one that will offer a more personal interpretation and make your composition more dynamic. Think also about how the figure relates to the borders of the picture: here, for example, the tall, narrow format is relieved by the strong diagonal of the figure, creating a design that is at once balanced and visually arresting.

▶ **Mari Temes** Suzie Balazs,
pastel
Often the mass of a figure
implies a geometric shape. This
pastel portrait, for example,
resembles a triangle, one of the
most common shapes seen in
seated figures, as it provides an
inherent sense of balance. But
Balazs adds vitality to the picture
by positioning the head at an
angle, thereby making the
triangle asymmetrical.

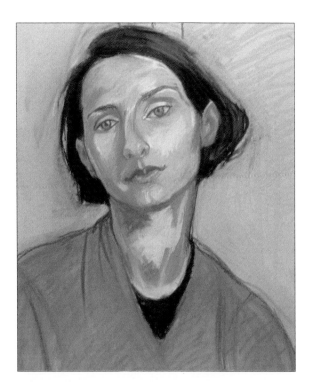

▼ **After the Swim** Jeremy
Galton, *oil*
Introducing figures into a
landscape gives an immediate
sense of scale and often
contributes to the balance and
interest of the composition. To
create the appropriate mood
for the painting, Galton has
placed the figure group low
down in the picture area,
surrounded by the vast expanse
of sand, sea and sky. The flat
horizontal spaces provide a foil
and a contrast for the small, busy
area at the bottom.

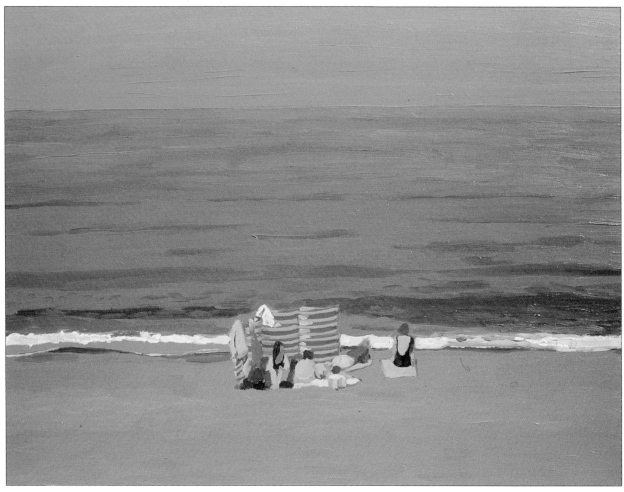

Q & A
CONVEYING MOOD

How can I make my portraits and figure studies more expressive?

Painting a portrait involves much more than simply achieving a likeness. Your painting should also say something about the character and personality of the sitter, projecting an emotional impact that arouses a sympathetic response in the viewer. Expressing emotion is as important as the physical details of the subject, and once you are able to communicate emotions through your painting, the experience becomes much more satisfying, both for you and for the

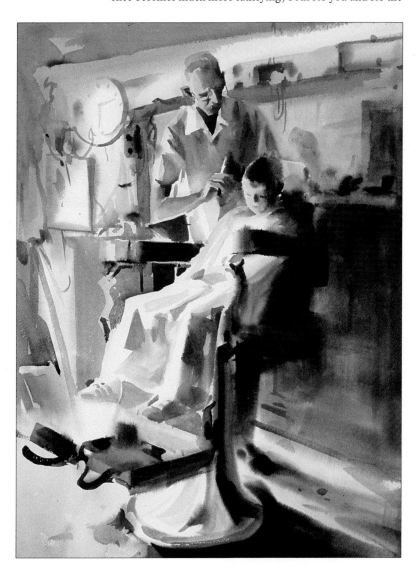

The Old Barbershop Douglas Lew, *watercolour*
To be sure that your portraits and figure studies have emotional impact, it is advisable to do some planning in your mind before the actual painting begins. Think of the elements of the picture – light, shadow, colour, composition, the pose – and how you can orchestrate them to express what you want to say about your subject. The tender, nostalgic mood of this painting results from a combination of all these factors – in particular, the mellow light softens and dissolves the forms in the interior, giving the painting a slightly out-of-focus, dreamy quality, which is perfectly suited to the subject.

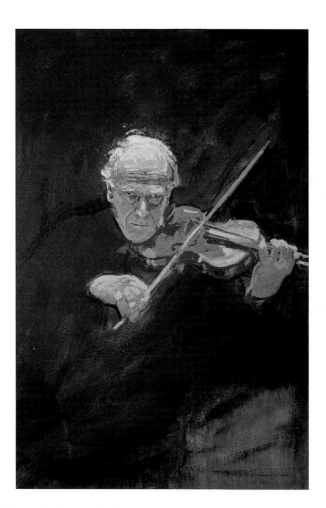

Sir Yehudi Menuhin, KBE
Henry Mee, *oil*
It is the portrayal of the inner life and character of your subject, rather than a mere physical likeness, that makes a portrait memorable. In this portrait of the distinguished violinist Sir Yehudi Menuhin, Henry Mee presents a study of a man completely immersed in his art, even possessed by it. The dramatic focus of the portrait is created by the vivid contrast between the starkly illuminated head, hands and violin and the surrounding darkness – an excellent example of lighting used for psychological and emotional emphasis.

viewer. The first step to this end is to plan the mood of every portrait *before* you begin painting.

Everyone has their own aura; some people radiate energy and vitality, while others have an air of serenity and composure. Ask yourself: "What is it about this person that makes me want to paint him/her? What am I trying to portray, and how best can I communicate this to the viewer?"

There are a number of visual pointers that will help to express emotion in your paintings. Choice of colours is important. Tonal values and degrees of contrast, the composition, the pose, the paint handling, and the softness and hardness of edges – each of these elements plays a role in expressing emotion. The following suggestions offer some starting points when you contemplate establishing the mood of a portrait.

Colour emphasis

Colour plays a major part in creating the mood of a painting. Rich, dramatic colours and strong contrasts might represent energy, passion and sensuality; cool, neutral colours and a harmonious scheme can be used to evoke serenity, nostalgia or melancholy. The emotional associations of certain colours – yellow is joyous, for example, while green is restful – are helpful in achieving a desired effect.

Tonal key

The term tonal key refers to the overall lightness or darkness of a painting. In a high-key painting, most of the colours are in the light-to-middle range of tonal values, and this may create a mood that is cheerful and sunny, or soft and romantic. In a low-key painting, the preponderance of dark tones may create a sense of drama, mystery or solemnity.

Study any successful painting and you will see that a certain harmony of tones and colours underlines the mood of the piece. The secret is to use a limited range of tones, because this gives greater power and directness to a painting; a work that contains too many different tones becomes spotty and confused, and the emotional message thus becomes dissipated.

···········Q & A···········

THE POSE

· ·

*Can you give me
some guidelines on
choosing a pose for
my sitter?*

One of the great joys of portrait painting is that each new sitter you encounter has a different personality, and it is up to you to decide how best to bring this out. Pose, expression and surroundings can all contribute to the final effect.

In choosing a pose, there are many options available. Take the time to plan carefully and decide whether you want the portrait to be head only, head and shoulders, half length or full length. In general a seated pose offers more possibilities – upright, leaning forward, hands in lap, and so on. A standing pose looks more formal, and from the model's point of view is less comfortable to hold for long periods, but nevertheless offers some interesting possibilities.

Even in a simple head-only or head-and-shoulders portrait, the aim should be to make the pose as interesting as possible. For example, a head viewed from a three-quarter angle, or at a slight angle to the shoulders, or upturned slightly, tends to give a more animated feel than a head that is viewed full-face.

▶ **Portrait of Sabina Corsini** Richard Foster, *oil*
The easy grace of the sitter leaning back among the cushions lends a refreshing air of informality to this portrait.

▲ **Portrait of Niel Henry**
Barry Atherton, *pastel*
It is impossible to contrive the "perfect" artistic pose – telling your model to move this way or that is counter-productive. Simply watch the model move around and when he or she assumes an interesting pose ask if it is comfortable to freeze. I like the snapshot approach of this portrait – it is as if the model has paused momentarily to reflect on something. The involuntary movement of the hand to the shoulder is a well-observed gesture.

Portrait of Lucine Rudolph Katchaturian, *sepia on gessoed wood panel*
When deciding on a pose, there are several questions to be asked. Does the pose convey the personality of the sitter? Will the outline of the figure create an interesting composition? And, last but not least, will the sitter be comfortable? This picture is successful on all three counts: the pose is relaxed and lighthearted; the sitter is obviously comfortable leaning on the back of the chair, and the positioning of the hands and arms lends vitality and interest to the basically triangular composition.

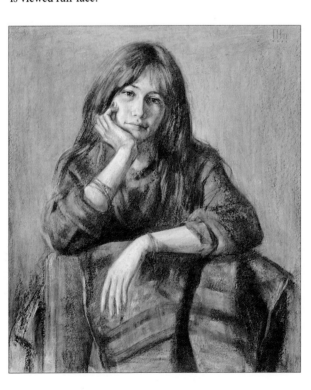

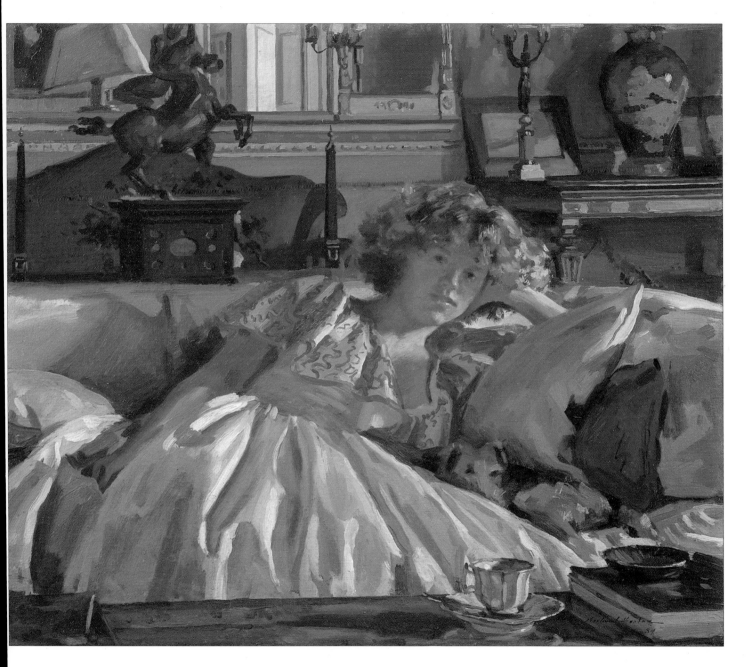

Above all, the pose should look natural and uncontrived, and characteristic of the sitter. The best portraits are those which manage to combine a sense of life and animation with a degree of restfulness (a pose that is too contrived can be irritating to look at when hung on the wall!).

Very often the sitter will unconsciously assume the pose which suits him or her best, and you will do well to accept this as the one you paint. Interfering with the sitter's natural inclinations tends to result in a pose which is awkward and uncomfortable – and this is likely to be reflected in the finished painting.

Engage your sitter in conversation while you are working as this helps to bring a natural and lively expression to the face, and allow plenty of rest breaks during a long sitting, otherwise your model will tire and begin to fidget.

Finally, make sure that you and your easel are placed at the correct distance from the model, as it is then easier to get the subject correctly proportioned. If you are painting the head only, get as close as possible – perhaps three to four feet away. For a half-length portrait, a distance of about nine feet is suitable, while for a full-length portrait about 15 feet may be necessary.

PAINTING CHILDREN

It isn't easy painting children – they won't keep still! Any suggestions?

The old film-makers' adage, "Never work with children or animals", will strike a chord if you have ever attempted to paint a small child with a very low threshold of boredom. However, with a degree of patience, forbearance and cunning, the task is not an impossible one. Rather than ask the child to adopt a pose and hold it, you will have more success if you paint "on the run", so to speak, when he or she is absorbed in reading a book, watching television or playing with a favourite toy. This way, the child remains reasonably still, but the pose and expression are mobile and lifelike, as opposed to frozen and slightly bored. In addition, the child will be less self-conscious and more likely to adopt a pose that is both natural and characteristic. The finished portrait will therefore be a lively and eloquent one that expresses the child's personality as well as offering a good likeness.

It is a good idea to make several sketches of your sitter and take photographs, too, if you wish.

▲ ▶ **Sketchbook page**
Andrew Macara, *coloured pencil*
Try to express the gestures and attitudes that typify a young child. Making quick gestural drawings of moving children helps to develop your speed and confidence so that you are better able to capture something of the energy and vitality of your subjects.

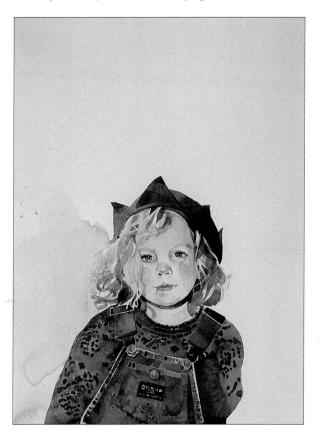

◀ **Alice** Ian Sidaway, *watercolour*
There is a wonderful duality about this portrait. Alice's frank, open gaze and her tomboyish clothes indicate youthful confidence and precociousness. At the same time, by placing her low down in the picture area and surrounded by white space, the artist emphasizes the childlike qualities of innocence and vulnerability.

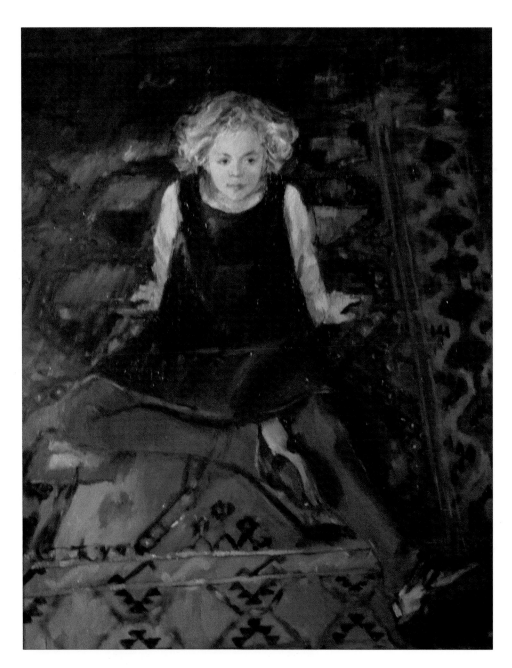

▶ **Portrait of Alex Lister**
Jane Corsellis, *oil*
Children are perfectly at ease
sprawling about on the floor,
which is how Jane Corsellis
chose to depict young Alex. The
result is a charming portrait
which captures the child's
personality as well as presenting
a good likeness.

Before you begin painting, it is a good idea to make
several sketches of your sitter – and take photographs, too, if
you wish. This helps you to warm up and gives your sitter
time to relax. It will also allow you to become familiar with
the gestures and facial expressions that are characteristic of
the child. As you draw, engage your sitter in conversation;
this will have a relaxing effect and will also enable you to
learn something about his or her particular interests. Choose
a simple pose that can be worked on over a period of time,
and allow for frequent rest periods: every 20 minutes or so
for a teenager, at shorter intervals for a young child.

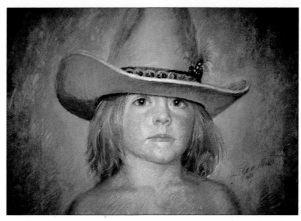

▲ **Playmates** David Curtis, *oil*
For toddlers, life is an adventure and the days are full of play. In this delightful study, David Curtis has caught his subjects unawares, thus capturing their natural gestures and expressions. The plain background helps to emphasize how completely absorbed the children are in building their sandcastle.

◀ **Cowboy Gilbert** John T Elliot, *oil pastel*
By moving in close and cutting out all background detail, John Elliot peeked under young Gilbert's hat and into his thoughts. A prop such as a favourite hat or toy can add much to the emotional, as well as visual, interest of the portrait.

Beach Study with Jonathan

David Curtis, *oil*

Unposed, "candid" portraits often say more than posed ones, in which it can be difficult to bring out the true nature of the child. If you have children, keep a sketchbook or a loaded camera in a handy place so that you can record those priceless moments that only happen once and, later, turn them into memorable paintings.

ART SCHOOL

TONED GROUNDS AND MONOCHROME UNDERPAINTING

"White fright" afflicts all artists, both amateur and professional, at some time or another. You know the scene: your model sits patiently, and your paints are neatly laid out ready; your brush hovers tentatively, but where to begin? The canvas stares back insolently, daring you to destroy its pristine whiteness.

One way around the problem is to prepare your canvas or board with a toned ground prior to starting the painting. A toned ground is simply a thin wash of heavily diluted paint, applied all over the canvas with a large brush or a rag. Its purpose is twofold: firstly, it tones down the stark white of the canvas or board, which can make it difficult to assess colours and tones accurately; and secondly, it helps to unify the overall colour scheme of the painting if small areas are allowed to show through between the succeeding brush-strokes.

Toned grounds traditionally are painted either in a neutral grey or earth tone, or in a colour that complements the finished colour scheme. For example, an undertone of subdued green, such as terre verte, lends a delicate coolness to the shadows in pinkish flesh tones. Alternatively, you might use a thin wash of yellow ochre or raw sienna to provide a subtle mid-tone that will tie together the darks and lights in the skin.

An oil ground can take around 24 hours to dry, so if you are using this you must prepare your canvas well in advance. An acrylic ground, on the other hand, will dry in minutes, allowing you to overpaint in oils during the same session.

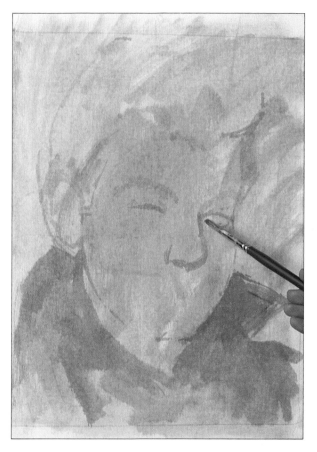

Underpainting

Traditionally the underpainting is done in a neutral monochrome, but there are no hard and fast rules. It's a good idea to practise with different coloured underpaintings to find out which colours suit your needs. In this portrait, Rosalind Cuthbert demonstrates how an initial underpainting in two colours allows the later stages of the painting to be developed with confident freedom.

◄ **1** Before starting the painting, the artist toned the canvas with a thin ground of brown madder and cerulean blue, roughly mixed and diluted with turps. The colour was lightly scumbled on and then rubbed down with a rag to produce an uneven tone which softened the stark white of the canvas and would help to emphasize the lights and darks of the underpainting. The basic forms of the head and shoulders are mapped out with dilute washes of cobalt blue and brown madder. At this stage the artist is drawing with the brush, finding her way around the head and establishing the composition of the portrait.

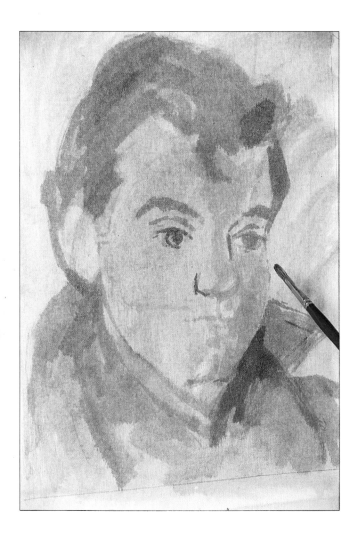

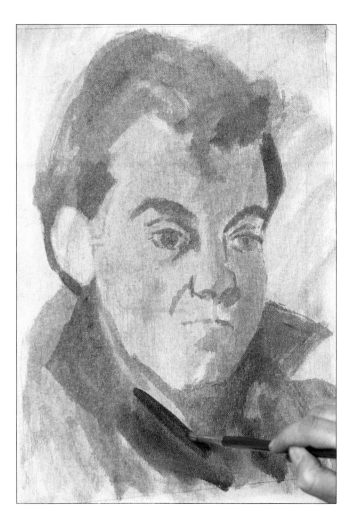

▲ **2** Still using the paint thinly, Cuthbert continues to construct the head, using tones of cobalt blue and brown madder to establish the main lights and mid-tones. The forms of the eyes and nose are drawn in with brown madder. Because the paint is so thin, corrections at this stage in a painting are easily made by wiping the paint with a rag soaked in turps, leaving you free from worry later on.

Monochrome underpainting

Another method traditionally used in oil painting is monochrome underpainting, in which the areas of light and dark and the main shapes and masses of the composition are blocked in with thin paint in shades of a neutral colour, prior to the overpainting. As well as overcoming the blank whiteness of the canvas, a monochrome underpainting also provides a blueprint for the finished picture. Because the paint is so thin, you can make any necessary adjustments to the composition, tonal values, drawing and proportions quite easily at this stage. This then leaves you free to concentrate on the application of colour, confident that the basic essentials of the composition are correct.

Choose a neutral or earth colour for underpainting, diluting it with turpentine to a thin, watery consistency. Use a large brush and block in the main shapes and masses only. Avoid putting in too much detail at this stage as this might restrict your freedom of brushwork at a later stage.

▲ **3** Now the artist develops the tones and introduces thin washes of orange madder in the hair, the lit side of the face and the neck area. The warm orange-browns and cool blues provide a base for the later application of warm and cool skin tones. Note that the artist is still working loosely at this stage; it is better to have a slightly untidy painting and to maintain a convincing solidity, than to start worrying about surface details and textures.

▶ **4** The darker tones are indicated using more intense mixtures of cobalt and brown madder. The brushstrokes are still broad and loose, to allow for refinements and modifications later. As you work, keep stepping back from the painting and look at it in terms of the whole head as well as the individual parts.

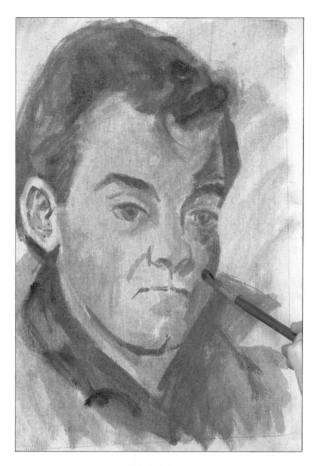

▼ **6** The artist switches to a smaller brush and continues blocking in the colours as she works across the image, relating each colour to the tone beneath and keeping faith with the underpainting. Each flesh tint in the face is kept as a separate shape. As you apply the colours, block in a small area at a time. If you try to take in too large an expanse, you will obliterate the lights and shades of the underpainting and lose the benefit of this preliminary guide.

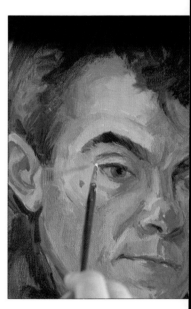

▶ **5** With the underpainting complete the artist is free to tackle the treatment of colour. The hair is painted with mixtures of cerulean, cobalt blue, orange madder and brown madder; these blue-brown tones give a soft tonality, so that the contrast between dark hair and light skin is not unnaturally sharp. The light areas of the face, predominantly warm, are achieved with mixtures of yellow ochre and cadmium red, plus white. The shadow areas, generally cooler, are achieved with mixtures of cobalt blue, brown madder and white. The lips are painted with carmine and cadmium red.

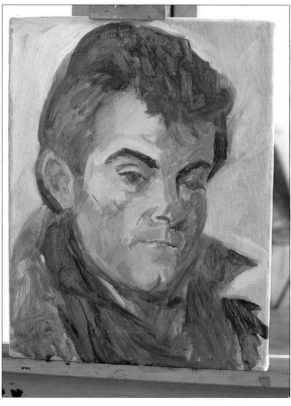

▶ **7** With the portrait complete, you can see how the forms and tones established in the early stages have guided the portrait through all its phases, yet produced a fresh, spontaneous study. The flesh tones have a warmth and vitality stemming from the optical flicker achieved by the use of the complementary opposites of red/yellow lights and blue/green shadows.

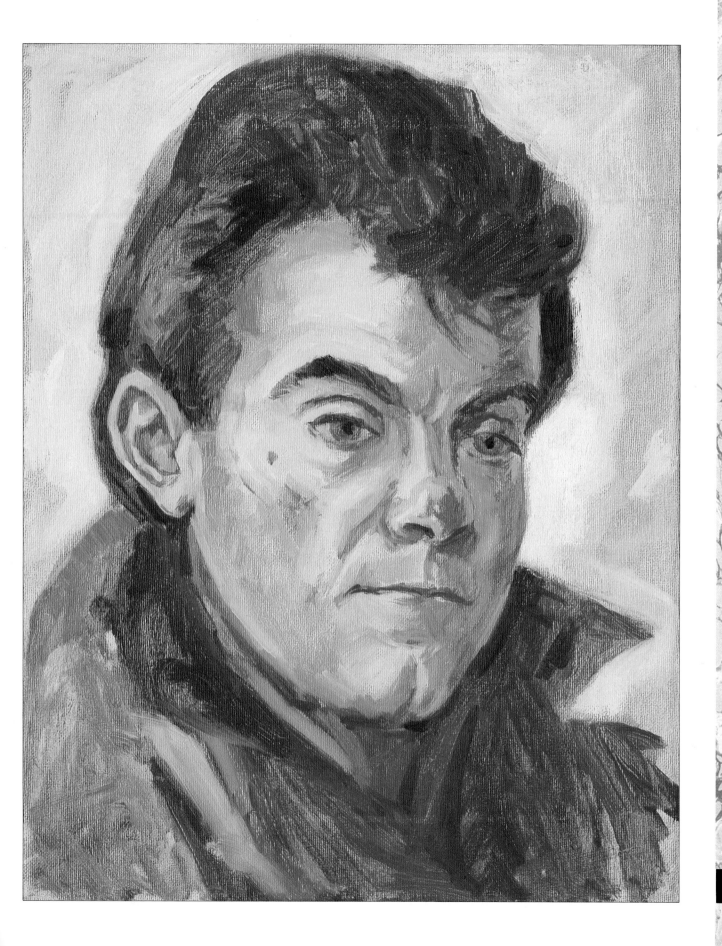

......... Q & A
UNIFYING THE PICTURE

My painting looks spotty and confused. Have I used too many colours?

When a few colours are continually repeated and intermixed, a certain harmony will naturally arise.

When you are painting portraits and figures, do not fall into the trap of treating each feature or area individually, like the pieces of a jigsaw. In some amateur portraits, the hair, skin, clothing and background are kept as distinct and separate areas of colour. If you concentrate too hard on literal details -- black hair and a red sweater – your finished picture will lack any feeling of harmony. Instead, it will have a stilted, artificial feel, as if you had been painting by numbers. What the artist of a portrait of this type has failed to notice is the interplay of flowing light and luminous shadow that gives strength and unity to the painting.

A way of avoiding this pitfall is to adopt some of the unifying devices used by many great masters. These include using a restricted palette of colours; repeating colours throughout the composition, and massing tones and colours together.

The most obvious unifying device is the use of a restricted palette. When a few colours are continually repeated and intermixed, a certain harmony will naturally arise. Sir Joshua Reynolds once criticized a picture submitted to him by a young painter; he observed that the picture lacked harmony because it contained too many colours, adding that a picture should look as if it was "all painted from the same palette".

Look at paintings by Reynolds, Gainsborough and Whistler and you will observe that black, white, red, yellow, blue and brown form the palette from which their splendid harmonies are drawn.

Even if you prefer using a wide range of colours, it is possible to achieve unity by interweaving the colours, or one dominant colour, throughout the picture. This creates an overall harmony that not only ties the composition together but also strengthens the mood of the portrait.

Last, but not least, we come to the arrangement of light and dark tones in the picture. It is the broad pattern of light and dark masses that first strikes the eye when we look at a picture; subconsciously, we assimilate this long before the subject, treatment and details are clearly apprehended. If

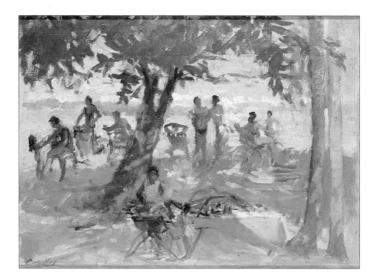

Beach Party Jane Corsellis, *oil*
Unifying a picture means tying together all the elements – colours, shapes and tones – so that they work harmoniously rather than competing for the viewer's attention. Corsellis achieves colour unity by restricting her palette to just a few colours, which are repeated throughout. Notice also how the figures – repeated shapes, but with enough variety to hold our interest – create a visual rhythm that pulls the picture together.

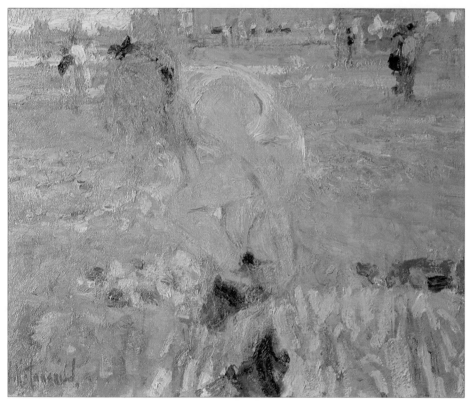

Going Home Arthur Maderson, *oil*
Although the overriding impression in this painting is one of brilliant colour, Maderson ties his composition together by allowing two complementary colours – violet-blues and oranges – to predominate, thus strengthening the composition. On closer inspection, we can see the myriad flecks and dabs of juxtaposed colour with which the artist weaves his rich harmony. As with Corsellis's painting (above) consistent brushwork throughout the picture also has a unifying effect.

this patchwork of lights and darks is to have unity, they must appear to fuse into a homogeneous mass.

Areas of light and shadow can be used as powerful connecting elements that unify the isolated parts of the composition. Look for opportunities to merge together neighbouring objects which share the same tone; for example, you might run the shape of the sitter's dark hair or clothing into the dark tone of a cast shadow. Merging small shapes together in this way creates a unified, interlocking design that gives the picture greater impact.

It is a good idea to start by making a tonal sketch of your subject, to clarify the light and dark shapes and check that they form a balanced arrangement. Similarly, at the painting stage, begin by blocking in the broad masses of light and dark, without any detail. Having established the main tonal pattern, you can start to add the gradations, halftones and refinements by which the painting is gradually softened, enriched and perfected.

LEARNING FROM THE
MASTERS
· ·
WHISTLER

Whistler was born in America, but at the age of 21 he left for Paris to become an artist. There he was inspired by the work of Velásquez and of the Dutch masters of the 17th century, and became a friend and protegé of Gustave Courbet, whose Realism influenced his early work.

In 1859 Whistler moved to London, where his contact with the Pre-Raphaelites awakened his interest in aestheticism. During the 1870s a succession of finely composed portraits called "Arrangements" were among his greatest achievements. *Harmony in Grey and Green* reflects his quest for the perfect harmony of line, form, tone and colour.

▲ This detail from the left of the picture shows how Whistler used rapid gestural brushstrokes to describe the folds of the sitter's robe as it hangs over a stool. The form and modelling of the fabric are built up with washes and scumbles of thin paint over a dark underpainting. Whistler was a perfectionist and made repeated changes and corrections to his paintings.

▲ Whistler disliked paint that looked overworked or "embarrassed". This detail shows how he worked in simple flat areas of paint to build up the planes of the hand without overstating them.

Whistler worked with very thin paint, adding copious amounts of turpentine to produce what he called his "sauce". Here he scrubbed the paint loosely across the surface, allowing the grey-brown underpainting to modify the white of the muslin and produce a range of subtle tones.

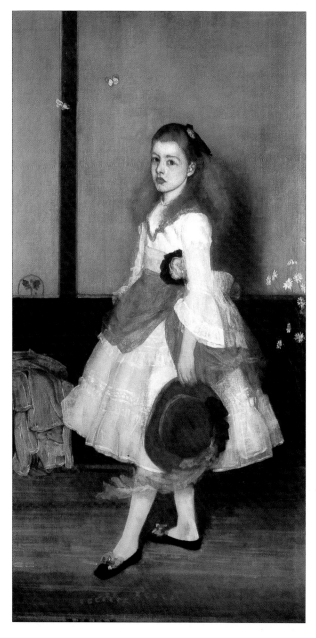

Harmony in Grey and Green: Miss Cicely Alexander, 1872–3
oil on canvas
189.9cm × 97.8cm
(74¾in × 38½in)
Tate Gallery, London

This simplified diagram of the portrait demonstrates the masterly simplicity of its composition. The subtle placing of the tiny butterflies, the white daisies, the feather on the hat and the artist's personal monogram at centre left lead the eye in a circular direction, while the composition is balanced and stabilized by the linear shapes of the black dado rail and detail strip on the wall behind the subject.

Whistler greatly admired the work of the Spanish painter Diego Velásquez (1599–1660), whose influence is evident in this enchanting portrait. Miss Cicely Alexander gazes out of the canvas with the haughty disdain of a Spanish *Infanta*, perfectly poised and beautifully dressed, with an elegant plumed hat in her hand. The painting is subtitled *Harmony in Grey and Green*, reflecting Whistler's preoccupation with producing a picture which, in its colour scheme and arrangement of masses of light and dark, should be beautiful in itself. The artist used a limited palette of black, white, siennas, umbers and ochres, while delicately applied areas of pure colour, scattered around the composition, introduce a note of lightness and freshness.

133

CONVEYING ATMOSPHERE

· ·

My portraits seem too hard-edged. Can you diagnose the problem?

One of the biggest stumbling blocks for the amateur painter is the paint-by-numbers approach, in which each part of the painting is given a precise outline which is then filled in with the actual colour of the object. Lacking confidence, the artist gives equal emphasis to every part of the picture and is afraid of allowing shapes to merge into one another. The result is a collection of disparate details that tire the viewer's eye as it darts from one spot to another, not knowing where to settle. And because the picture is painted so tightly, it is dry, characterless and two-dimensional.

So the message is – loosen up! Don't treat heads, necks, arms, torsos and so on as an assorted collection of nuts and bolts, but seeing them as part of a whole. In the same way, the figure and background should not appear to be separate and distinct from each other, but should form a homogeneous mass, enveloped in a unifying light.

Think of any of Rembrandt's later portraits and you will see the validity of this. Save for one or two significant highlights, his figures are veiled in shadows and half-lights, with no harsh outlines. Rembrandt understood the power of suggestion; he allowed the viewer to use his own imagination, to *experience* the picture rather than merely look at it.

Following Rembrandt's example, emphasize what you consider to be the vital elements of your composition and play down the nonessentials. For example, if you wish to draw attention to the sitter's face, paint it with more finish than other areas of the picture, or illuminate it with lighter colours. Elsewhere, do not dwell on details but suggest them by painting them more loosely, blurring edges between areas, and toning down colours.

In effect, what you are doing is to mimic the way in which the eye actually perceives things; because the eyes are constantly in motion, we see edges as soft unless we specifically focus on an edge, which then appears sharper. If you employ selective focus in this way – contrasting sharp detail with soft effects – you will give your portraits and figure studies the vital impression of air and atmosphere that brings them to life.

Portrait of My Father David Curtis, *oil*
By intentionally softening edges, particularly in those areas farthest away, the artist gives an impression of air, light and space surrounding the subject. Try not to begin your portrait with a precise preliminary outline, as this will inhibit the flow of your painting. Instead, indicate outlines and features with loose strokes which serve as a guide for the completed portrait, not a border that cannot be crossed. Work over the whole canvas at once – figure, background and clothing – so that everything flows together naturally.

Figure and background should form a homogenous mass, enveloped in a unifying light.

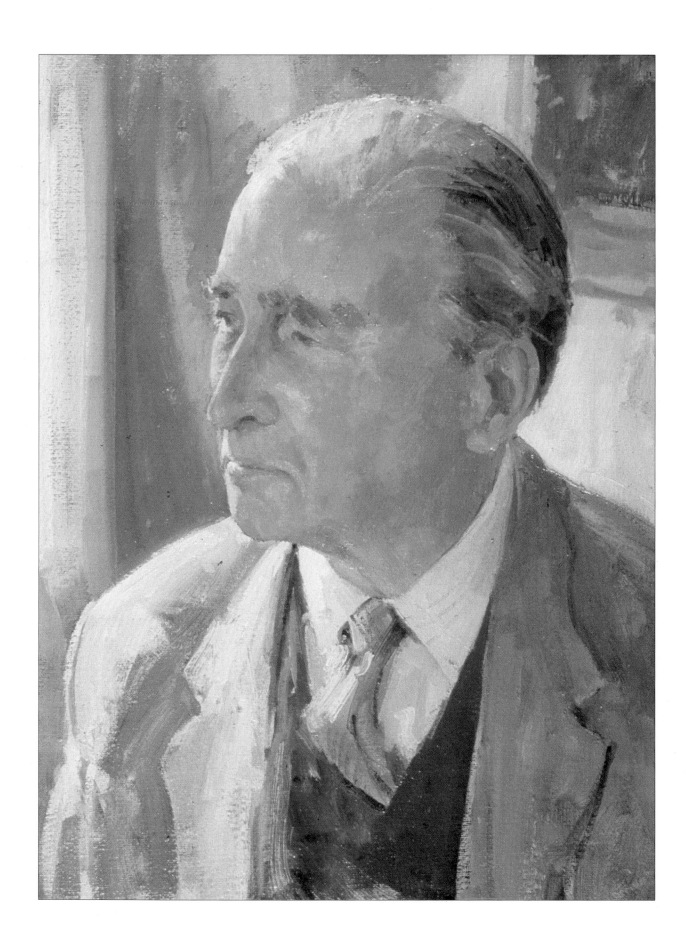

Corner of the Fair Trevor Chamberlain, *oil*
Here the atmosphere of a fairground on a bright, blustery day is vividly captured with the utmost economy of brushstrokes. The figures are not carefully delineated, but are dashed in quickly and deliberately blurred, to give an impression of movement and life.

The Performance Crawford Adamson, *oil on canvas*
Interior scenes, whether illuminated by daylight or by artificial light, offer interesting possibilities for exploring the effects of mood and atmosphere. Here, the artist evokes the smoky ambience of a crowded nightclub, the shadowy figures barely discernible in the dim light.

Doncaster Market Trevor Chamberlain, *watercolour*
The poetry of this picture derives from the soft, hazy light, which dissolves much of the detail and gives the scene a slightly ethereal quality. The artist created his soft, diffused effects by working mainly wet-in-wet. At the dry stage, a few sharper accents were added to give definition to the image.

Evening Light, Aristaig
David Curtis, *oil*
Light is the magical element that lends atmosphere to even the most ordinary subject. This beach scene was painted in late afternoon, when the last warm rays of the sun contrast with the cool shadows of evening.

TOM COATES
PORTRAIT: YOUNG MAN

Alla prima

In this portrait of a young man, artist Tom Coates uses the direct method of painting in oils known as *alla prima*, which means "at one sitting". The drawing, colour, composition and brushwork are constantly modified, each layer emerging from the previous one, gradually moving towards an integrated statement of the original idea.

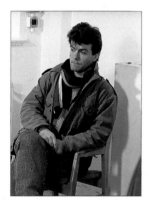

The model was posed in a relaxed position, one arm resting on the arm of a chair and his body turned slightly, presenting a three-quarter view to the artist. Natural light coming from a window to the right of the model helps to describe the volume of the figure.

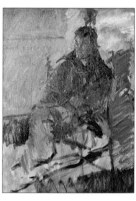

▲ **2** The initial forms and tones of the figures are loosely indicated. Coates keeps the paint thin and works with loose, scrubby strokes – that way he can keep his options open in case he decides to alter anything.

▲ **1** The canvas is first tinted with a neutral tone of raw sienna diluted with turps to a washy consistency. This is scrubbed into the canvas with a rag to create an uneven tone that is more sympathetic to work on than the bare white canvas.

When the ground is dry, Coates makes a very broad brush drawing of the model, using ultramarine and burnt umber. He keeps the brush moving rapidly over the canvas, trying to capture the essential gestures of the figure.

4 The artist begins to refine colours and forms, keeping the image fluid and constantly changing and readjusting as he works. The fleshtones are mixed from a basic palette of alizarin, carmine, cadmium orange, yellow ochre and white, neutralized with emerald green in the cool areas. The jacket is painted with sap green, emerald green and burnt umber, softened with white.

3 Here we see the portrait beginning to take shape, like a photographic image emerging in the developing tank. Note how the figure, face and background are all progressing at more or less the same pace.

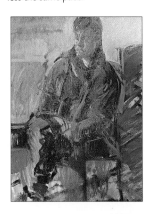

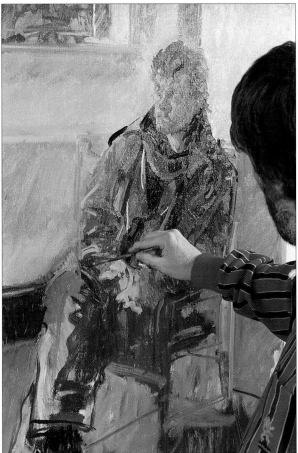

5 The artist refers to the subject constantly as he matches both the local and reflected colours found in the face. Each plane is clearly defined, and this structural approach helps to define the forms of the face. Coates stands well back from the painting and holds the brush about halfway down the handle, removing the temptation to become lost in particular details to the detriment of the overall composition.

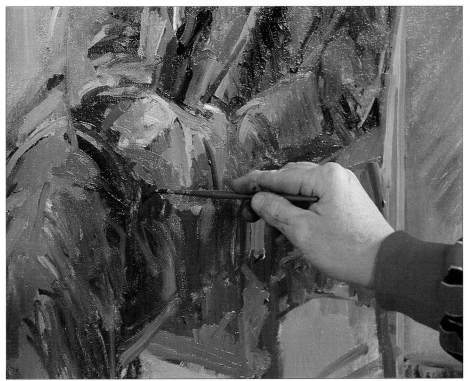

6 The direct approach gives Coates the freedom to develop the forms – here the hands – as a series of tones. The forms emerge from the arrangement of light and dark tones and warm and cool colours.

139

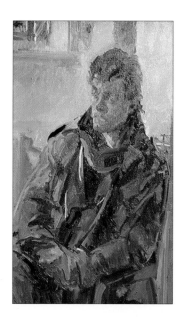

7 The artist consolidates the colours in the background with mixtures of cerulean blue, yellow ochre and white. By constantly working back and forth between subject and background, he ensures that the two are properly integrated and that there is an overall unity to the composition. It also helps the artist to mix the correct flesh tones for the face and hands by relating them to the background tones.

9 The artist keeps moving around the canvas, restructuring and redefining where necessary. Here he is working on the model's jacket and scarf, enriching the colours and tones. He models the form of the hands more precisely, using mixtures of burnt sienna, cobalt blue and alizarin for the shadow areas. The colours of the scarf consist of alizarin, carmine, Winsor orange, ultramarine and mauve, plus white. Hog hair brushes tend to lift paint off, so Coates prefers to work with soft brushes.

8 Working with large masses in the beginning stages has allowed the artist to proceed in a logical sequence from broad outlines to smaller, more precise details. Here he is using a small brush and white paint to flick in some energetic strokes that give an impression of movement in the street outside the window. Even at this stage the brushwork is still loose and fluid.

10 In the final stage, the artist completes the background and the chair, and adds the finishing touches to the figure. Notice how the sienna ground glows through the cool greys of the background as well as in areas of the figure; this not only unifies the colour scheme of the picture but also creates an impression of light. The composition is effective, too, with the dominant figure offset by the angular shapes in the background.

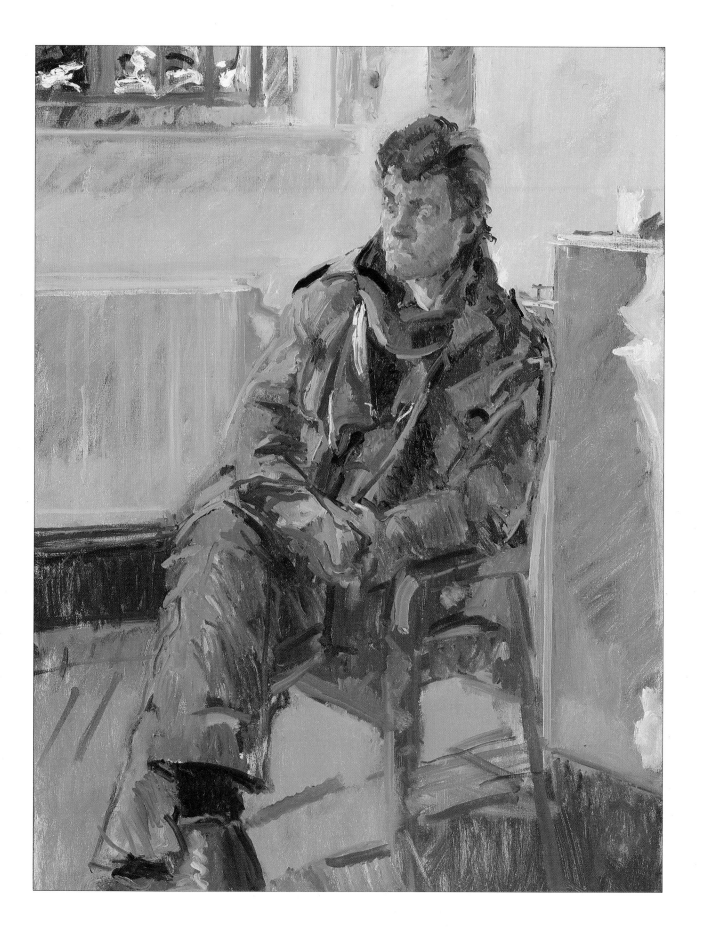

INDEX

CREDITS

The author and the publishers would like to extend their grateful thanks to all the artists who submitted their work for this book of which only a selection appears on these pages.

We would also like to thank the following art galleries and individuals for allowing us to use some of their artists:

Jonathan Thorpe p.79, p.80 (Julia Cassells), p.81 (Julia Cassells).

New Academy and Business Galleries p.7, p.40 (Rudolph Katchaturian), p.45, p.47, p.48 (Jane Corsellis), p.62 (Rudolph Katchaturian), p.71, p.74 (Jane Corsellis), p.89 (Jane Corsellis), p.91 (Edmun Aivazian), p.99 (Jaqueline Hines and Linda Atherton), p.100 (Linda Atherton), p.105 (Richard Foster), p.116 (Barry Atherton), p.119, p.120, p.121, p.122 (Andrew Macara), p.123, p.131 (Jane Corsellis).

The Scottish Gallery p.38 (Alison Watt), p.87 (Alison Watt), p.97, p.136 (Crawford Adamson).